IMAGE BUILDING

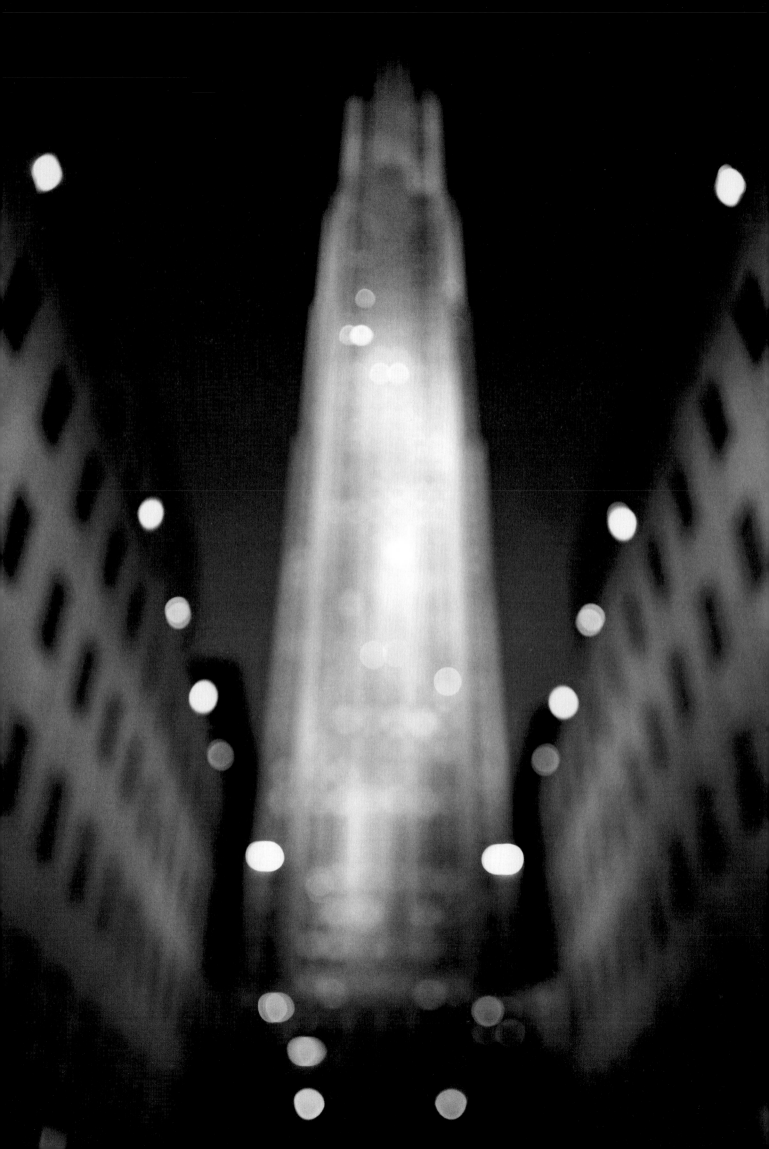

THERESE LICHTENSTEIN
WITH ESSAY BY MARVIN HEIFERMAN

PARRISH ART MUSEUM, WATER MILL, NY
DELMONICO BOOKS•PRESTEL MUNICH, LONDON, NEW YORK

IMAGE BUILDING

How Photography Transforms Architecture

EVERY BUILDING
ON THE
SUNSET
STRIP

EDWARD RUSCHA

1 9 6 6

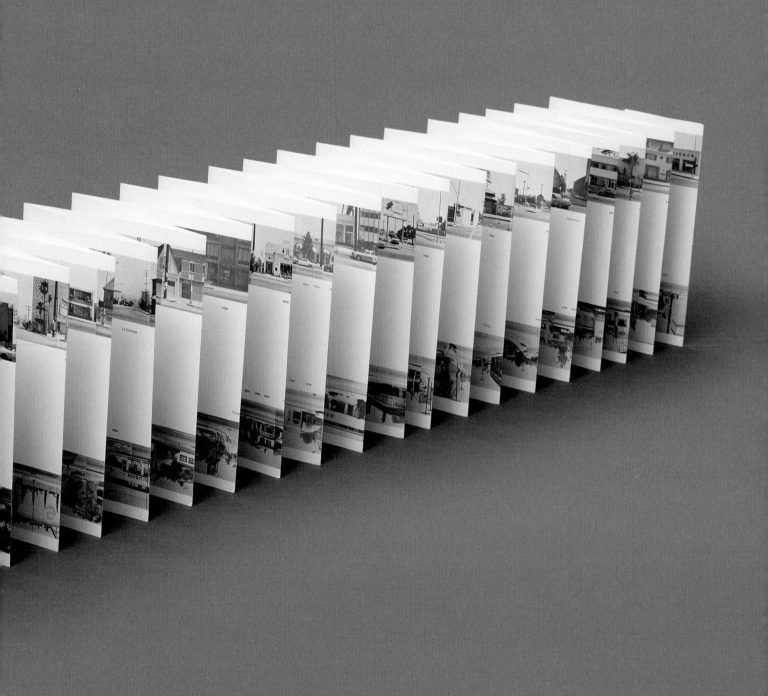

Published in conjunction with the exhibition:

**Image Building:
How Photography
Transforms Architecture**

Parrish Art Museum, Water Mill, NY
March 18—June 17, 2018

Frist Center for the Visual Arts,
Nashville, TN
July 20—October 28, 2018

PARRISH ART MUSEUM

Parrish Art Museum
279 Montauk Highway
Water Mill, New York 11976

© 2018 Parrish Art Museum

© 2018 texts by Marvin Heiferman,
Therese Lichtenstein, and Terrie
Sultan

First published in 2018 by the
Parrish Art Museum and
DelMonico Books•Prestel

Parrish Art Museum
279 Montauk Highway
Water Mill, New York 11976
parrishart.org

DelMonico Books, an imprint of
Prestel, a member of Verlagsgruppe
Random House GmbH

Prestel Verlag
Neumarkter Strasse 28
81673 Munich

Prestel Publishing Ltd.
14–17 Wells Street
London W1T 3PD

Prestel Publishing
900 Broadway, Suite 603
New York, NY 10003
www.prestel.com

ISBN 978-3-7913-5729-4

Library of Congress Control Number
2017953071

A CIP catalogue record for this book is
available from the British Library.

Design and production:
Eileen Boxer
boxerdesign.com

Managing Editor:
Alicia G. Longwell

Associate Managing Editor:
Michael Pinto

Printer: Trifolio SRL, Verona, Italy

Cover: Balthazar Korab (Hungarian,
1926–2013), detail of *860–880 Lake
Shore Drive Apartments, Chicago, IL*,
1960. Chromogenic print with metallic
paper base, 11 × 11 inches. Courtesy
Korab Image, Christian Korab,
Minnesota. © 2018 Korab Image. Title
page: Hiroshi Sugimoto (Japanese,
born 1948), *Rockefeller Center*, 2001.
Gelatin silver print, 58¾ × 47 inches.
Courtesy the artist. © 2018 Hiroshi
Sugimoto. Frontispiece (pl. 1, p. 4–5):
Ed Ruscha (American, born 1937),
Every Building on the Sunset Strip,
1966. Book, 7⁵⁄₁₆ × 5¹³⁄₁₆ × ⁹⁄₁₆ inches.
Collection of Beth Rudin DeWoody,
New York. © 2018 Ed Ruscha, Photo:
Gary Mamay. Page 12: Ezra Stoller
(American, 1915–2004), *Johnson Wax
Administration Building and Research
Tower, Frank Lloyd Wright, Racine, WI*,
1950. Gelatin silver print, 20 × 16
inches. Courtesy Yossi Milo Gallery,
New York. © 2018 Estate of Ezra
Stoller. Back cover: Iwan Baan (Dutch,
born 1975), detail of *Torre David #1*,
2011. Chromogenic print,
72 × 48 inches. Courtesy the artist
and Moskowitz Bayse, Los Angeles.
© 2018 Iwan Baan.

*Image Building: How Photography
Transforms Architecture* is made possi-
ble, in part, by the generous support
of the Century Arts Foundation and
the Robert Mapplethorpe Foundation.
Additional support is provided by The
Mr. and Mrs. Raymond J. Horowitz
Fund for Publications.

Contents

8
Foreword and
Acknowledgments
TERRIE SULTAN

13
Lenders to the Exhibition

14
What Goes Up: Architectural
Photography and Visual
Culture
MARVIN HEIFERMAN

47
Architecture after
Photography
THERESE LICHTENSTEIN

140
Exhibition Checklist

144
Author's Acknowledgments
and Photo credits

Foreword and Acknowledgments

TERRIE SULTAN, DIRECTOR, PARRISH ART MUSEUM

In November 2012, the Parrish Art Museum took public occupancy of its new building, designed by Herzog & de Meuron, in Water Mill, New York. For the previous two years, after groundbreaking in July 2010, the structure was a distinctly private enterprise in which the architects, the contractors, and we, the clients, interacted on a daily basis to guide the design we envisioned into reality. Even as we walked through the ever-changing landscape of the construction, the elements cohering into a distinct entity, we could not fully imagine what a lived experience in the Museum would entail.

For the official opening, we were fortunate to have the photographer Iwan Baan with us. He spent the entire day documenting the building and the inaugural events through his own lens. It wasn't until I reviewed his images that I fully understood how this building so emphatically occupied the landscape, and how the interior and exterior spaces both reflected their surroundings

and embraced the human interactions that would make the Museum a unique, transformational space for art.

Over the five years that followed, the Parrish has been equally fortunate to have welcomed a host of other creative and renowned architectural photographers to the Museum. Through their eyes we have been able to appreciate more thoroughly the variety of ways people encounter and engage with this special building. We were thus prompted to consider the complex and dynamic relationship between physical space and structure, and how spaces and structures are represented through the particular interpretation of photographic images.

The idea that photography can document as well as shape the way we see the spaces we inhabit is one of the innovations of the medium, influencing the modernist movements of the twentieth century as much as it continues to inform the practice in our own time. *Image Building: How Photography*

Transforms Architecture explores the myriad connections found among spectator, photographer, and architect, from the 1930s to the present. Documenting how yesterday's and today's photographers depict the relationship between a building's identity and the people who inhabit, work in, visit, or simply look at it, *Image Building* reveals not only how photography frames our understanding of architecture, but also how this understanding may be layered, reinforced, or transformed across time.

Photographs can emphasize or alter what a building means, and in doing so can show how a building's function, as well as our comprehension of it, can change over time. In the past, photographers would choose between black-and-white and color, sharp contrast and soft focus, straightforward and dramatic framing to record their subjects. Contemporary photographers incorporate new technologies of digital manipulation to draw attention to how we understand the world through

visual images. They involve the viewer in the social, psychological, and conceptual implications of buildings and spaces. Constructing a public perception—a mental or actual image of a structure—has become an essential component to architectural practice, affecting architects' thoughts about how buildings will look in addition to how they are constructed or experienced. Buildings and the way they are photographed are visible symbols of a society's desires and the social, economic, and aesthetic concerns of an era.

The exhibition and this companion volume are organized with dynamic juxtapositions of images that yield layered meanings. By promoting opportunities to compare and contrast works from different historical periods, the exhibition and the book show architectural images in a new light. Mobility of perception and meaning are examined through various thematic lenses: "Domesticity and the American Dream" includes

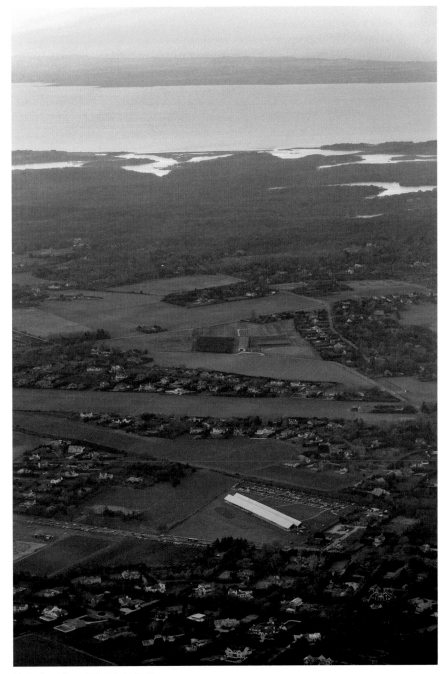

Photo: Iwan Baan. © 2018 Iwan Baan.

Julius Shulman's famous images of Case Study homes, which became known to the public through representation in architectural journals and design magazines that promoted a comfortable middle-class suburban American lifestyle. Shulman's images can be seen in relation to James Casebere's contemporary photographs of his constructed models of suburbia, which present an ironic, perhaps

melancholy critique of the American dream. Robert Adams's aerial views of suburban California sprawls are also viewed in this context. Such comparisons highlight the role of architectural photography as symbolic and psychological, an emphatic projection of a period's desires and fantasies. "Cityscapes" compares and contrasts 1930s bird's-eye images by Samuel Gottscho and Berenice

Abbott with present-day views by Andreas Gursky, Thomas Struth, and Iwan Baan. "Public Places/Spaces" features images of libraries, museums, theaters, commercial buildings, and churches by Shulman, Candida Höfer, Hiroshi Sugimoto, and Thomas Demand. "Re-Imaging Modernist Architecture: Present–Pasts" looks at photographs by Balthazar Korab and Ezra Stoller in relation to contemporary images by Sugimoto and Thomas Ruff. By combining different contexts and frames of meaning, *Image Building: How Photography Transforms Architecture* invites viewers to actively experience structures and spaces in novel and expanded ways and to meditate on and critically evaluate what we know and how we know it. These innovative perspectives help viewers reflect on architecture in challenging and provocative ways.

First and foremost, we are indebted to our guest curator, Therese Lichtenstein, for conceiving the theme for *Image Building*. She worked tirelessly to craft a precise and illuminating selection of images from an astonishingly diverse and compelling array of artists with a broad range of approaches and techniques. Her essay provides a concise overview, examining matters of time and space in architectural photography and focusing on the relationship between past and present, and between inhabited spaces and memory. Contributing essayist Marvin Heiferman has added his distinctive voice to this vital topic, addressing the centrality of photography in defining and perpetuating the iconic nature of buildings and places, and in producing photographic narratives both simple and complex.

The exhibition and publication would not have been possible without the energy and administrative acumen of our project team. We are grateful to the lending museums, galleries, estates, and artists who agreed to participate in this endeavor, and to designer Eileen Boxer, who envisioned this publication.

We thank her for her insight, as we do Anna Jardine for her copyediting.

At the Parrish, members of the staff diligently brought this project to fruition. Michael Pinto, Curatorial Associate, is to be especially commended for his outstanding efforts in uniting the myriad publication components. Alicia Longwell, Lewis B. and Dorothy Cullman Chief Curator, Art and Education; Registrar Chris McNamara; Preparator Robin Klopfer; Director of Communications Susan Galardi and our colleagues at Sutton; Cara Conklin-Wingfield, Education Director; Chris Siefert, Deputy Director; Eliza Rand, Associate Development Officer for Foundations and Major Gifts; and Barbara Jansson, Administrative Assistant—all were indispensable in realizing the full potential of *Image Building*.

We acknowledge with much appreciation the enthusiasm and sponsorship of the Leadership Committee, whose generous support facilitated the

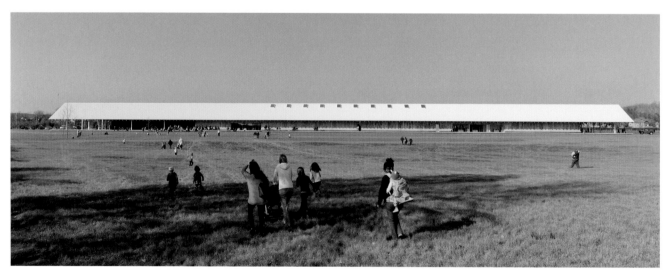

Photo: Iwan Baan © 2018 Iwan Baan.

organization and presentation of the exhibition and the accompanying publication: Century Arts Foundation and the Robert Mapplethorpe Foundation. Additional support is provided by The Mr. and Mrs. Raymond J. Horowitz Fund for Publications. We deeply value the public funding for the Parrish from Suffolk County. The Museum's programs are made possible, in part, by the New York State Council on the Arts, with the support of Governor Andrew Cuomo and the New York State Legislature, and by the property taxpayers from the Southampton School District and the Tuckahoe Common School District.

Thank you to the many public and private collectors who generously agreed to share their works with the public for the exhibition: 303 Gallery, New York; 601 Artspace, New York; Ammann Gallery, Cologne, Gabrielle Ammann; Iwan Baan; Stacy and Lance Boge, New York; James Casebere; Dallas Museum of Art; David Zwirner Gallery, New York/London; Beth Rudin DeWoody, New York; Gagosian; George Eastman Museum, Rochester, New York; Getty Research Institute, Los Angeles; Korab Image, Christian Korab, Minnesota; Marian Goodman Gallery, New York; Matthew Marks Gallery, New York; Moskowitz Bayse, Los Angeles; The Museum of the City of New York; Sean Kelly, New York; Ted and Mary Jo Shen, New York; Marcia Dunn and Jonathan Sobel, New York; Sonnabend Gallery, New York; Hiroshi Sugimoto; George Yabu and Glenn Pushelberg; Yossi Milo Gallery, New York; Two Private Collections.

We are thrilled that this exhibition will be presented by the Frist Center for the Visual Arts in Nashville. Many thanks to Director Susan Edwards and her team for their early interest in the project and for recognizing the value of sharing this exhibition with their viewers.

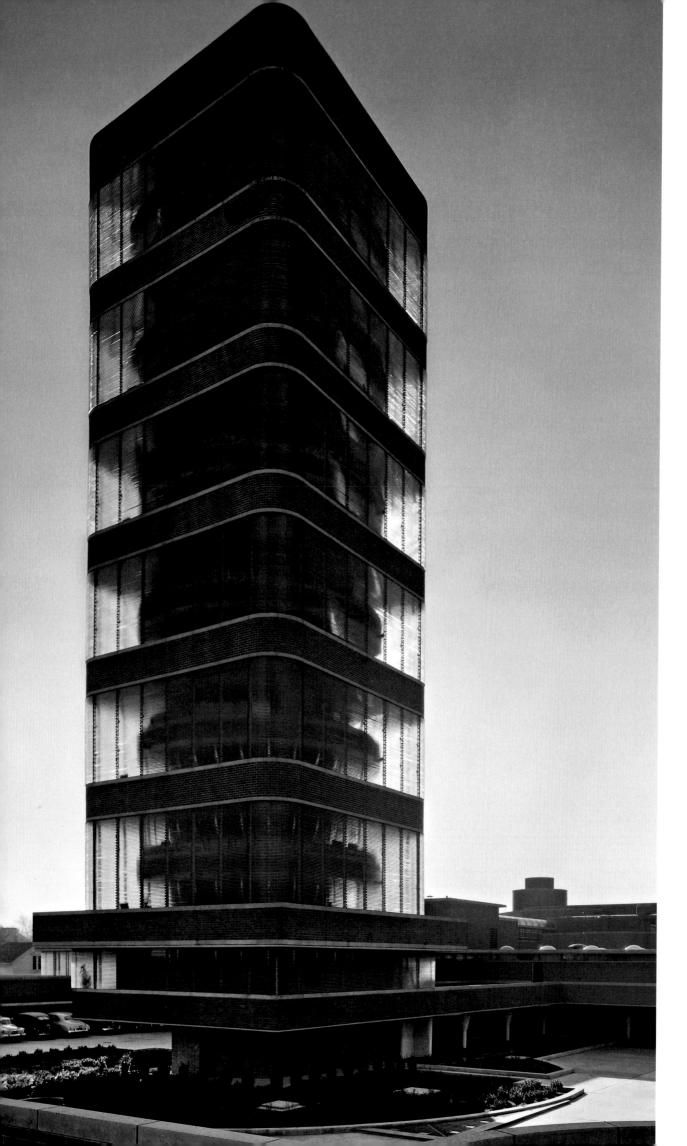

Lenders

303 Gallery, New York

601 Artspace, New York

Ammann Gallery, Cologne, Gabrielle Ammann

Iwan Baan

Stacy and Lance Boge, New York

James Casebere

Dallas Museum of Art

David Zwirner Gallery, New York/London

Beth Rudin DeWoody, New York

Gagosian

George Eastman Museum, Rochester, New York

Getty Research Institute, Los Angeles

Korab Image, Christian Korab, Minnesota

Marian Goodman Gallery, New York

Matthew Marks Gallery, New York

Moskowitz Bayse, Los Angeles

The Museum of the City of New York

Sean Kelly, New York

Ted and Mary Jo Shen, New York

Marcia Dunn and Jonathan Sobel, New York

Sonnabend Gallery, New York

Hiroshi Sugimoto

George Yabu and Glenn Pushelberg

Yossi Milo Gallery, New York

Two Private Collections

What Goes Up:
Architectural Photography and Visual Culture

MARVIN HEIFERMAN

It is impossible to look at a photograph of a building without imagining what its demise might look like.

Vivid flashbacks to the "most widely observed and photographed breaking news event in human history," the collapse of New York's World Trade Center towers after a terror attack on September 11, 2001, are deeply engrained but not yet buried away in personal and cultural memory (fig. 1).[1] The tallest buildings in the world when completed in 1973, the Twin Towers were subjects of photographic scrutiny well before their fall. Photographs of architectural renderings and scale models of them circulated in the 1960s to announce their future construction (fig. 2). Then came the images of groundbreaking ceremonies, then more as floor after floor of the buildings' steel structures rose to transform the skyline of Lower Manhattan.

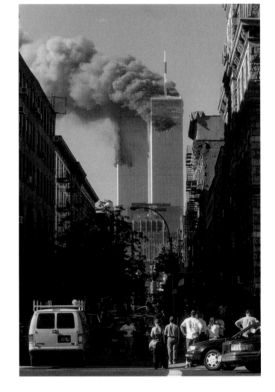

Once the towers were finished and filled with tenants and visitors, the picture-taking never abated. The North Tower was photographed by sightseers in the observatories on an upper floor and the roof of the South Tower. Photographs were made by pedestrians looking up from nearby streets, from the shores of Brooklyn and New Jersey, by passengers on boats and ferries crisscrossing New York Harbor and by those in window seats on airplanes flying over or into New York, who couldn't resist capturing glimpses of the over-scaled, often criticized, but stubbornly iconic buildings. Images of the Twin Towers, like flash cards symbolizing New York itself, were predictably featured on map covers, visitors' guides, and on ten-for-a-dollar postcards.

fig. 1 Crowds on West Broadway view the twin towers of the World Trade Center on the morning of September 11, 2001. Photograph by Stacy Walsh Rosenstock/ Alamy Stock Photo.

fig. 2 Governor Nelson Rockefeller looks at a model of the World Trade Center, with its architect Minoru Yamasaki, at the New York Hilton Hotel in Manhattan, January 19, 1964. Photograph by John Campbell/ NY Daily News via Getty Images.

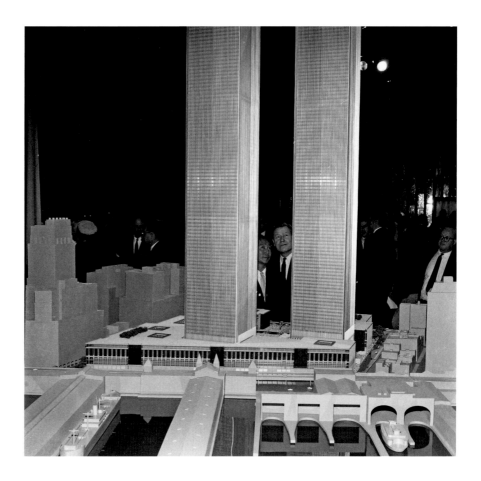

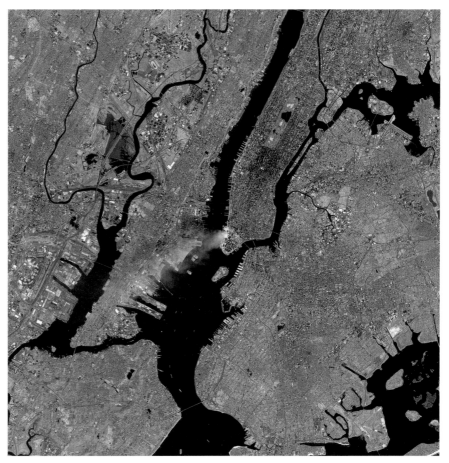

fig. 3 True color image depicting the aftermath of the 2001 World Trade
Center attack taken by the Enhanced Thematic Mapper Plus (ETM+) aboard
the Landsat 7 satellite on September 12, 2001, at roughly 11:30 a.m.
Eastern Daylight Savings Time. Photograph by USGS Landsat 7 team, at
the EROS Data Center. Image courtesy NASA.

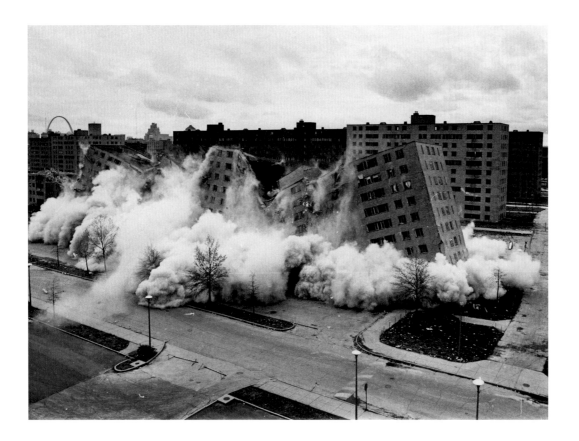

But when what went up—symbols of progress, pride, and profit—came down, both the event and the photographic documentation of it were deeply destabilizing. And for many, both remain so. On a blue-sky day that turned nightmarish, incredulous locals, tourists, photojournalists, and even NASA astronaut Frank Culbertson, 250 miles above the earth on the International Space Station, watched and photographed as the towers crumbled (fig. 3). Within hours, all the previous images that marveled at and spoke to the metaphoric nature of architectural form became haunting records of vulnerability and loss.

September 11 was not, of course, the first instance in which photographs of architecture under duress were taken and shared. Throughout World War II, photographs of bombed and decimated cities were widely reproduced in newspapers and picture magazines. Wide publication of elegiac images of the demolition of New York's Pennsylvania Station—which began in late 1963—played a major role in mobilizing public support for establishing the city's Landmarks Preservation Commission in

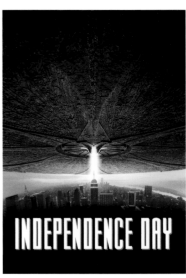

fig. 4 Demolition of Pruitt-Igoe, April 1972. Image courtesy U.S. Department of Housing and Urban Development, Office of Policy Development and Research.

fig. 5 Movie poster for *Independence Day* (20th Century Fox/ 1996). Image courtesy PhotoFest Inc. NYC.

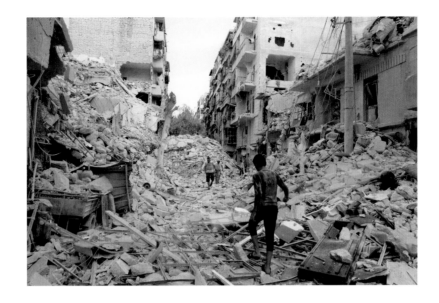

1965. In the early 1970s, the live television broadcast and sensational wire-service photos of detonations leveling the high-rise buildings of the controversial Pruitt-Igoe housing development in St. Louis—the first major architectural commission for Minoru Yamasaki, who later designed the World Trade Center—spectacularized the problems of urban planning and redevelopment that plagued cities across America (fig. 4).

It could be argued, too, that media attention focused on the dynamiting of two of Las Vegas's fabled but aging hotels—the Dunes in 1993, the Sands in 1996—infused energy into a growing pop cultural trend: the destruction of iconic structures became a major plot point in, and furnished the poster imagery for, big-budget action films. In literal blockbusters like *Independence Day* (1996), *Armageddon* (1998), and *The Day After Tomorrow* (2004), the Empire State, Transamerica, Chrysler, and Capitol Records buildings toppled, and the Statue of Liberty, the White House, the Eiffel Tower, and the Washington Monument came under attack (fig. 5).

More recently, images detailing homes destroyed by Hurricane Katrina's violent path through New Orleans in 2005, irreparable damage done to ancient sites by the Taliban and ISIS, and the ravaged streets of Aleppo and other locations in Syria speak to the power of images in documenting architectural damage as well as shaping the news (fig. 6).

fig. 6 People inspect a damaged site after airstrikes on the rebel
held Tariq al-Bab neighborhood of Aleppo, Syria, September 23, 2016.
Photograph by Reuters/ Abdalrhman Ismail.

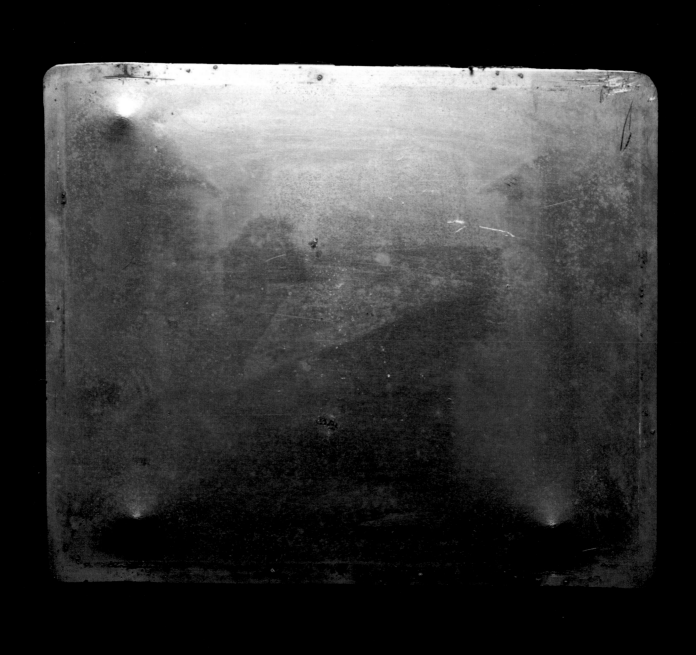

fig. 7 Joseph Nicéphore Niépce (French, 1765–1833), *View from
the Window at Le Gras,* 1826 or 1827. Heliograph plate. Courtesy the
Gernsheirn Collection, Harry Ransom Center, The University of Texas
at Austin. Digital image courtesy J. Paul Getty Museum, 2002.

If what is seen is not easily unseen, perhaps the combined impact of all those images of buildings falling sheds light on the need to make and value photographs of buildings that stand.

Since the introduction of photography in the early nineteenth century, its relationship to architecture has been complex. The built world was pictured often during the medium's early decades because, quite simply, the exposure times necessary to make photographs were long; if people or the leaves on trees wouldn't or couldn't stay still, architecture did. The earliest known surviving photograph, made by Joseph Nicéphore Niépce in France in 1826 or 1827, shows a view of buildings from an upper-story window (fig. 7). In 1835, the British imaging pioneer Henry Fox Talbot used a small camera obscura outfitted with a lens to make some pictures of his country house, which he described as "well suited to the purpose, from its ancient and remarkable architecture" and believed to be the first building "to have drawn its own picture."[2]

It was in the second half of the nineteenth century—as photographic technology improved and more of the medium's uses, audiences, and markets became evident—that architectural photography blossomed as a pursuit and a profession. Enterprising photographers in the 1850s, including Francis Frith, Félix Bonfils, Robert Macpherson, and Maxime Du Camp, hauled bulky equipment and necessary chemistry to Egypt, the Holy Land, Rome, Greece, and the Middle East, where they composed artful images of picturesque ruins and historic sites that they would mass-produce and profitably sell to libraries and as souvenirs to well-to-do travelers and armchair tourists (fig. 8). Other European photographers journeyed even farther, often for more bureaucratic reasons, to inventory the people, infrastructure, and cultural exotica of newly colonized lands.

Still other photographers, staying closer to home, participated in ambitious national and urban photographic surveys, documenting historic buildings, monuments, and construction projects. In Paris in the 1860s, photographers such as Charles Marville produced extensive photographic records of the demolition and reconstruction of Parisian

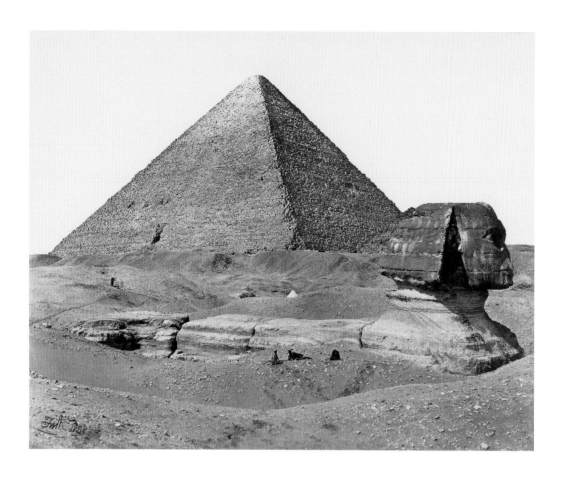

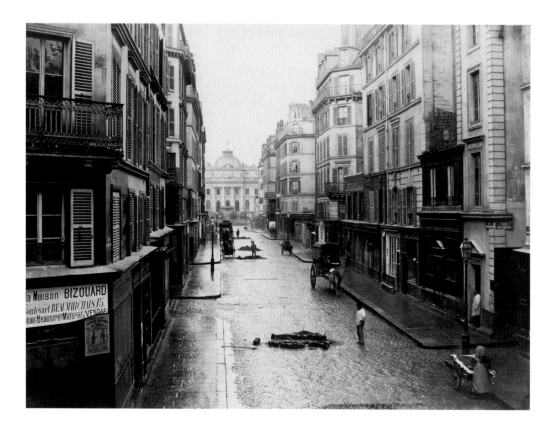

fig. 8 Francis Frith (English, 1822–1889), *The Great Pyramid and the Sphinx*, 1858. Albumen silver print, 15⁹/₁₆ × 19⁵/₁₆ inches. The J. Paul Getty Museum, 84.XM.633.12.

fig. 9 Charles Marville (French, 1813–1879), *Rue de Constantine*, ca. 1865. Albumen silver print from glass negative, 10¾ × 14½ inches. Metropolitan Museum of Art, New York, Purchase, The Horace W. Goldsmith Foundation Gift, through Joyce and Robert Menschel, 1986, 1986.1141.

streets and boulevards, pictures so exquisitely balanced and compelling that they not only captured the city at that moment in time, but also influenced how the city would be imagined and experienced in the future (fig. 9).[3]

Architectural photography was called into service, early on and just as powerfully, to fulfill more specifically commercial functions. In a paper read to attendees of a South London Photographic Society meeting in 1860, the Reverend F. F. Stratham described how

> the capitalist, who is about to build a villa, or to lay out a new street, is beginning to think of the figure it will cut when photographed and exhibited for letting or for sale in the auctioneer's window; and he is perhaps induced by this consideration to employ an architect and bargain for a little display of ornamental skill, instead of confining himself as heretofore to the four solid square walls.[4]

If photographs functioned to make builders and architects more self-aware of their product, they also came to play central roles in the study of architectural history, in the practice of restoration and repair, and in publicizing and commemorating architectural show-stoppers at special events such as the World's Columbian Exhibition of 1893 in Chicago and subsequent world's fairs. Once the halftone printing process was introduced in the late nineteenth century, more easily reproduced and distributed images became efficient promoters of architectural achievement and unprecedented tools in reputation building. By the 1890s, every major city had its own architectural photographers.[5]

It was after World War I that the hybrid nature and practice of architectural photography revealed itself more fully. Photographs of the built world continued to function as they always had: as documents of accomplishment, signifiers of progress, expressions of pride, and marketing tools. The data embedded in them was put to use by engineers, historians, mapmakers, tax authorities, and insurance agents. But it was the rise of modernism—reflecting social concerns and utopian aspirations, and introducing a lighter materiality into architecture—that would usher in an optimism and a new aesthetic into architectural imaging. Novel approaches to architectural design and culture were pioneered at the Bauhaus school in Dessau, Germany, and covered in photographically illustrated journals, among them the

Italian *Domus* (founded in 1928) and the French *L'Architecture d'aujour-d'hui* (founded in 1930).[6] "The abstraction of the International style seemed almost made for photographic expression," the writer Akiko Busch noted, as buildings whose forms seemed to be drawn in steel and sheathed in glass were now "defined as much by light as by more material substance."[7]

This modernist mind-set and style, emerging as multiple media outlets were creating larger venues, markets, and audiences for photographic images, enabled innovative practitioners to enter the field of architectural photography and transform it. Werner Mantz, Albert Renger-Patzsch, and other German photographers understood that "radical changes in the architectural vocabulary . . . led to a similarly radical change in the photographer's view of architecture" (fig. 10).[8] Large firms specializing in architectural photography—Hedrich Blessing in Chicago, Nyholm & Lincoln in New York, and Dell & Wainwright in London—began to dominate the field in the 1920s by catering to the most prominent architects and developers. Within another decade or two, independent practitioners such as Samuel Gottscho in New York and Julius Shulman in Southern California brought fresh creative energy and innovative visual strategies to the images they were commissioned to shoot. Gottscho's dramatic and sometimes vertiginous photographs of Manhattan's Art Deco skyscrapers were, in their own way, glamour portraits as much as architectural studies. Shulman, shooting buildings by Richard Neutra and other modernists working in and around Los Angeles and Palm Springs, devised the distinctive spatial setups and styling that would reconcile the representation of a newly casual mid-century lifestyle and the documentation of austere avant-garde architectural design.

And increasingly throughout the twentieth century, art photographers found themselves as fascinated with the built world as more specialized architectural photographers were, if for other reasons and to very different ends. Gottscho's advice to commercial photographers was: "Suppress your ego, follow the client's lead. Think how best to serve him."[9] Art photographers working for the most part for themselves had as much freedom to question architecture's complex role in culture as to celebrate it. Some managed to do both, as Berenice Abbott did, working on *Changing New York*, a sprawling, multiyear enterprise

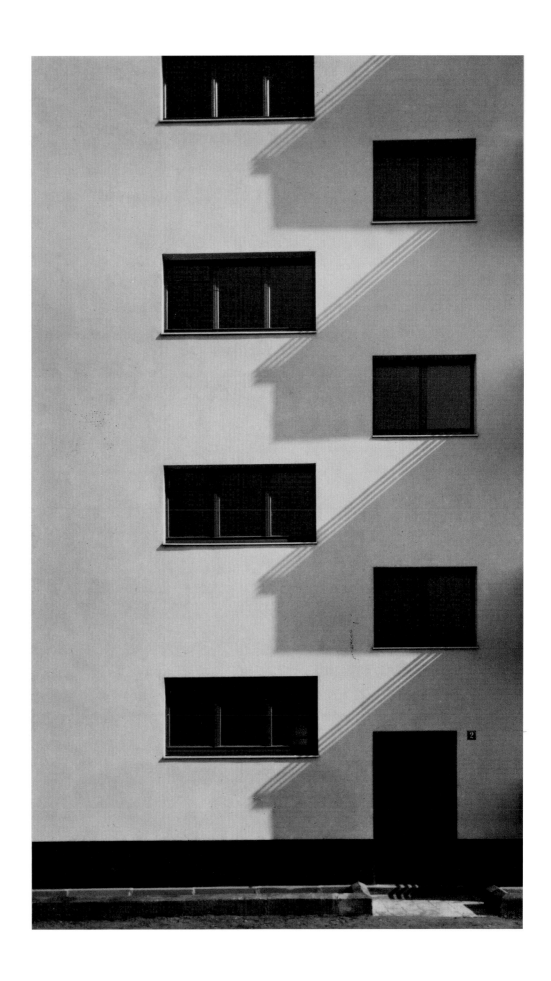

fig. 10 Werner Mantz (German, 1901–1983), *Detail Kalkerfeld settlement,*
Cologne, 1928, 1928, printed 1977. Gelatin silver print, 8⁵/₈ × 5 inches.
Tate Modern, London. Purchased with funds provided by the Photography
Acquisitions Committee 2011, P79945. © 2018 Artists Rights Society (ARS),
New York / VG Bild-Kunst, Bonn. Digital image © 2018 Tate Modern, London.

funded by the Federal Art Project in the midst of the Great Depression (pl. 2). "How shall the two-dimensional print in black and white," she asked, "suggest the flux of activity of the metropolis, the interaction of human beings and solid architectural constructions, all impinging upon each other in time?"[10]

That was, of course, a challenge photographers of architecture faced in the past and would grapple with in the future, even after color photography was introduced and became more commonplace in the field. The successful rendering of architecture demands a heightened sense of multiple forces at work as well as a photographic eye attuned to drama, narrative, nuance, and time itself. "Photography is space, light, texture, of course," observed Ezra Stoller, "but the really important element is time—that nanosecond when the image organizes itself on the ground glass."[11] In fact, in architectural photography, time never stands still, and is ever-changing. "The photographer seeks to reveal aspects of space through his understanding of the effects of time," the architectural photographer and curator Richard Pare wrote. "Time past, in the cumulative age of the building, time present in the photographer's moment, and time future in our perception of each image."[12]

Architectural imaging is further complicated by the fact that photography is not a passive documentary medium, but a transformative one, a medium that, as the philosopher and cultural critic Walter Benjamin noted in 1934, is "incapable of photographing a tenement or a rubbish-heap without transfiguring it."[13] Like portrait photography, architectural photography looks at facades but is charged with revealing character, arguing for distinctiveness and defining presence. Like still-life photography, it deals in metaphors. Like landscape photography, it strives to strike a balance between the everyday and the sublime. Like advertising and fashion photography, architectural photography glamorizes and sells. And like art that expresses itself through photography, architectural photography can just as easily trigger questions as answer them.

As a result, and in the process of image-making, choices abound. Structures may be viewed close-up or from afar. People and vehicles appear in images or do not. Compositionally, buildings can be anchored in the center of and dominate the photographic frame, just as, for emphasis, they are sometimes nudged away from the median line.

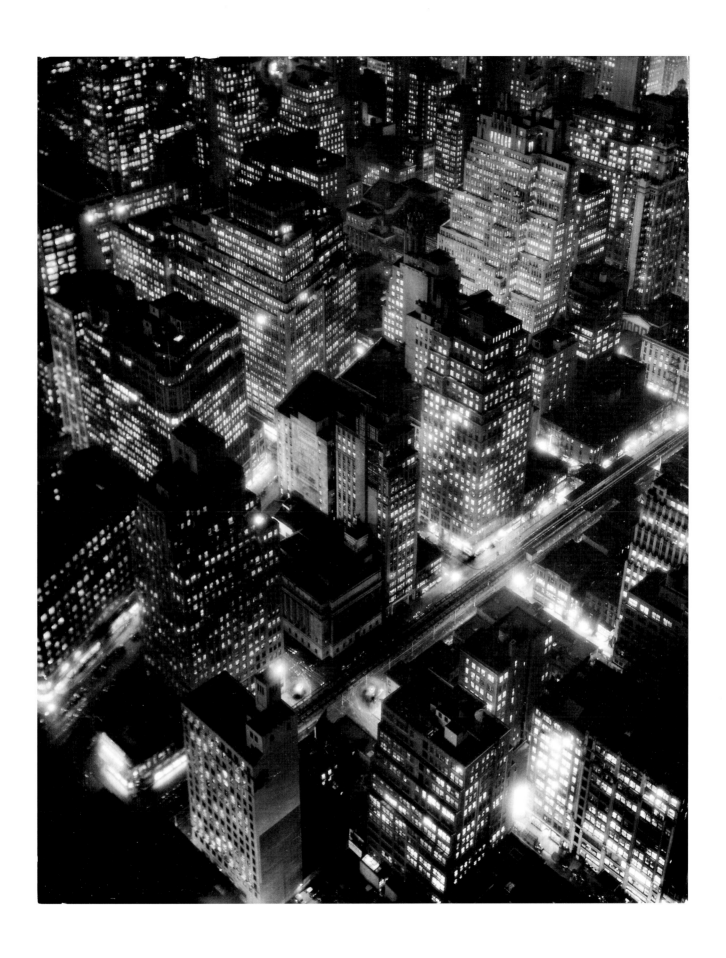

PLATE 2 BERENICE ABBOTT (AMERICAN, 1898–1991), *THE NIGHT VIEW,* 1934

Depicted in isolation or in relationship to what surrounds them, buildings can be shot head-on, from one side or another, and from various street-level, elevated, and aerial vantage points. Volumes and voids, horizontals and perpendiculars and diagonals, flat planes and textures, subtle tonalities and stark silhouettes, straight lines and curved ones all work with or against one another within the borders of the image itself. Lens choices, lighting decisions, and a host of production options, from retouching to print size, must all be carefully considered if three-dimensional objects in space are to be rendered successfully in flat, two-dimensional images and do their jobs convincingly.

"Architecture, real architecture," Lewis Baltz said in a 1993 interview, "always defies reduction into two-dimensional representation; if not it's hardly architecture at all." But as Baltz went on to explain, "Architectural photography is a closed system that refers primarily to its own canons of representation and only tangentially to the architecture in question"[14] (fig. 11). Ultimately, the net effect of the goals photographers have, the pictorial conventions they embrace, and the innovations they devise determines the impact of and values that radiate from the images they produce.

In his 1936 essay "The Work of Art in the Age of Mechanical Reproduction," Walter Benjamin posited that the widespread distribution of images of artworks would eventually strip away the aura of the objects pictured. Ironically, architectural photography is tasked with creating an aura as often as it is with depicting what has been made concrete.[15] That is certainly what many of the commissioning agents of architectural imagery—developers, architects, builders, leasing agents, the architectural media—expect and pay for. Aura is also what the intended viewers of those images expect and want. But then so do, paradoxically, such photographers of the banal as Ed Ruscha and Stephen Shore, both masterly if seeming anti-stylists of everyday street scenes (fig. 12). So did Baltz, who claimed quotidian "sub-architecture" to be his true subject, but whose photographs have not only an undeniably distinct aura but an iconic look.[16]

Aura and iconicity often overlap and reinforce each other in the most successful of architectural photographs. Sensuous materiality, bold profiles, the solidity and bulk of buildings, their symmetries and eccentricities, when well captured in photographs, command attention

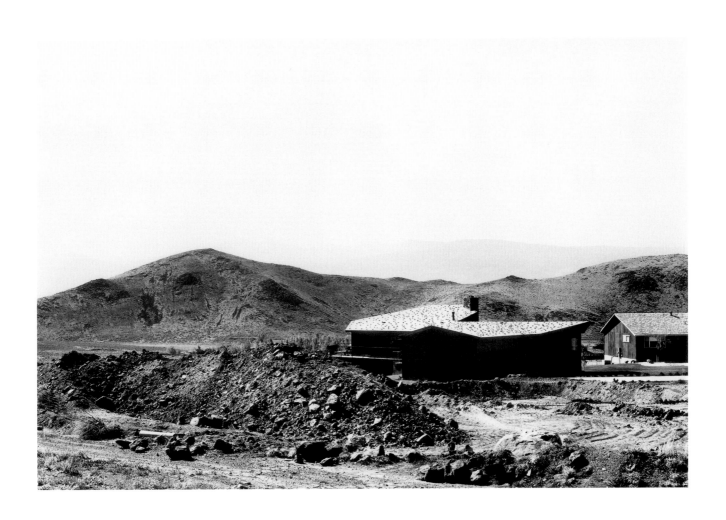

fig. 11 Lewis Baltz (American, 1945–2014), *Hidden Valley, looking
Southwest*, from the *Nevada* portfolio, 1977. Gelatin silver print,
8 × 10 inches. San Francisco Museum of Modern Art, Gift of Dr. Michael
R. Kaplan. © 2018 Estate of Lewis Baltz.

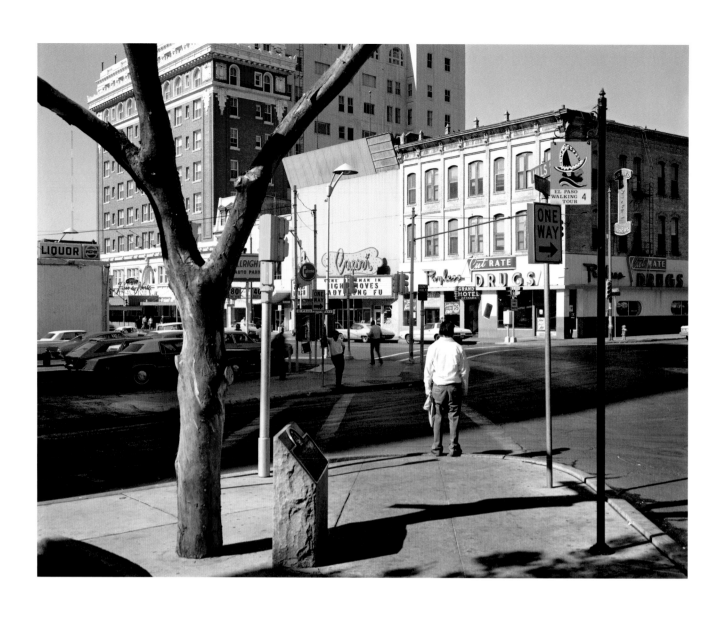

fig. 12 Stephen Shore (American, born 1947), *El Paso Street, El Paso, Texas, July 5, 1975,* 1975. Chromogenic print, 17 × 21¾ inches. Courtesy 303 Gallery, New York. © 2018 Stephen Shore.

fig. 13 Kodak Pavilion at 1939 World's Fair. Photograph by Peter Campbell/ CORBIS/ Corbis via Getty Images.

and reverberate in viewers' minds and memories. In addition, the conspicuous absence of people in so much of architectural photography heightens an image's iconicity and authority. Still, there is something both humbling and heroic that we sense when we look at architectural photographs. Images that pay homage to edifices we willfully construct are equally effective at suggesting what those places will look like without us.

In the late nineteenth century, the philosopher Charles S. Peirce speculated that photographs were of special interest because of the unique way they simultaneously recorded and resembled their subjects.[17] Perhaps his observation points toward something else that makes architectural photography particularly compelling. Even when captured in all their specificity in an image—and even when the photographs of them are small—buildings cannot avoid looking somewhat idealized and feeling larger than life.

Images become iconic when they encapsulate narratives effectively and circulate widely, as stereographic images of the Great Pyramids did when they were mass-produced in the 1860s, and as 3-D images of the Trylon and Perisphere did, when View-Masters were introduced and sold briskly at the 1939–1940 New York World's Fair as an alternative to the scenic postcard (fig. 13). Eye-catching images of Frank Gehry's eccentrically shaped, titanium-clad Guggenheim Museum Bilbao

were so frequently reproduced in the late 1990s that they helped kick-start an era of "starchitecture," in which audacious buildings functioned as billboards, and design, photography, and branding became irrevocably intertwined.

In his 1944 book *The Language of Vision*, the artist and designer Gyorgy Kepes described how "visual language is capable of disseminating knowledge more effectively than almost any other vehicle of communication."[18] That helps explain why architects and photographers have been eager to work together and how, throughout the twentieth century, not only architectural journals but

wider-circulation mass media magazines sought out graphically striking images to report on progressive architecture. "The architecture that was being produced in those days was shocking to most people," Julius Shulman recounted of the situation in mid-century America. "And magazines were constantly looking for that kind of story, because they knew it would have greater interest."[19]

Samuel Gottscho, whose work appeared regularly in *Town & Country* and *House & Garden,* "claimed that for several years in the 1930s he was practically the staff photographer for *American Architect* magazine."[20] Shulman's images became, a few decades later, graphic mainstays in John Entenza's influential magazine *Arts & Architecture.* In the 1950s and 1960s, crisp and dramatic images of Eero Saarinen's often sculpted-looking structures—most notably the swooping TWA terminal at Kennedy Airport in New York, shot so memorably by Ezra Stoller—were published in *Look, Harper's Bazaar,* and *Playboy* and played an undeniable role in shaping Saarinen's public profile and practice at that time.[21]

Shulman laid out the symbiotic relationship of architecture, photography, and the media succinctly, if a little self-servingly:

> Every architect I've ever worked for has become world-famous, because of the publicity they get. And the magazine people in New York used to tell me this all the time. I went to New York several times a year because I worked on a personal basis with every magazine. I mean every magazine that published anything about architecture interiors and exteriors. Shelter magazines as well as technical magazines. And book publishers, too. And the editors used to tell me, "Whenever a package of pictures came from you, we would all stop what we were doing and gather around the conference table and lay out the pictures"[22] (fig. 14).

Today, the excitement around perfectly conceived and beautifully produced images continues. "We call him the candy man," said Suzanne Stephens, deputy editor of *Architectural Record,* about the excitement that photographer Iwan Baan's visits to the magazine's office generated.[23]

But in reality, much of the architecture that shapes the built world and many pictures of it are not all that sweet. If media outlets generally favor congratulatory photographs over critical ones, image makers

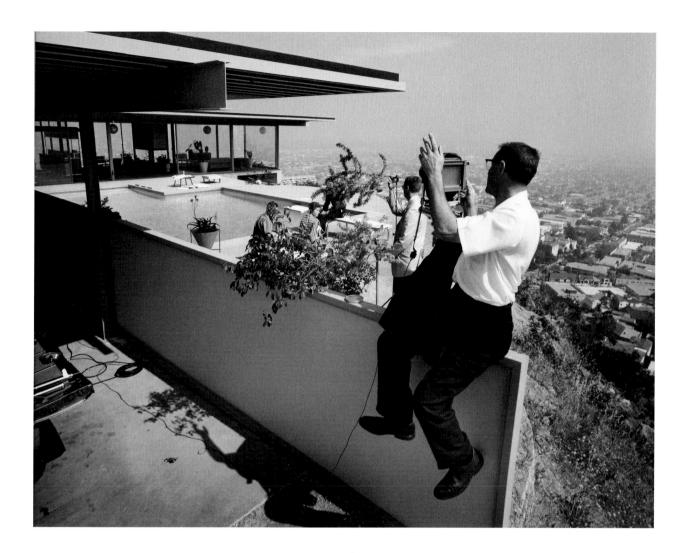

themselves, even those who service architecture and the media, are free to challenge conventions and approach architectural photography from multiple perspectives. In 2011, Baan, for instance, spoke of his interest in capturing how "people interact with their surroundings in ways fully out of control of the architect and city planner."[24] And in a TED Talk two years later, he presented a remarkable and far-from-decorous project in which he explored the ingenious homes that low-income squatters created for themselves in an unfinished, abandoned forty-five-story skyscraper in Caracas, Venezuela.[25]

Artists working independently and outside the architectural community have even greater freedom to ponder and comment on what gets built, and latitude in deciding how that is pictured. Ed Ruscha, in his often reprinted and now classic accordion-fold book *Every Building on the Sunset Strip* (1966; pl.1), created a twenty-five-foot-long

fig. 14 Julius Shulman photographing Case Study House No. 22, West Hollywood, 1960. Julius Shulman Photography Archive, Research Library at the Getty Research Institute, 2004.R.10. © 2018 J. Paul Getty Trust, Getty Research Institute, Los Angeles.

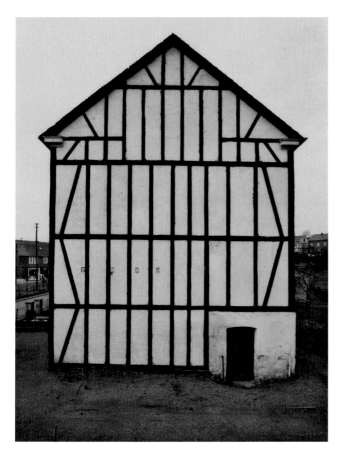
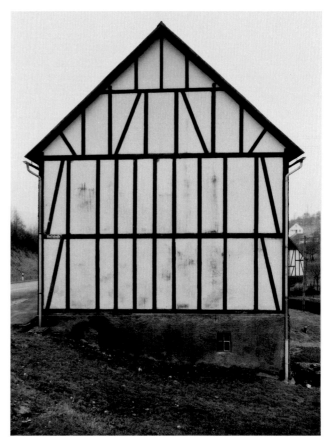
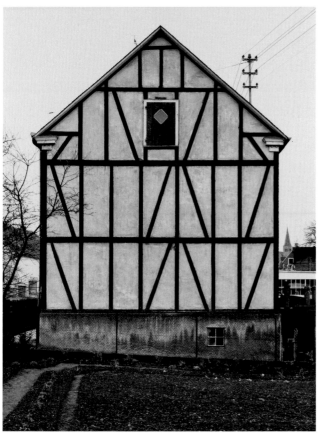
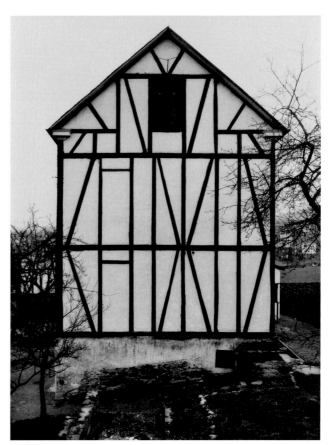

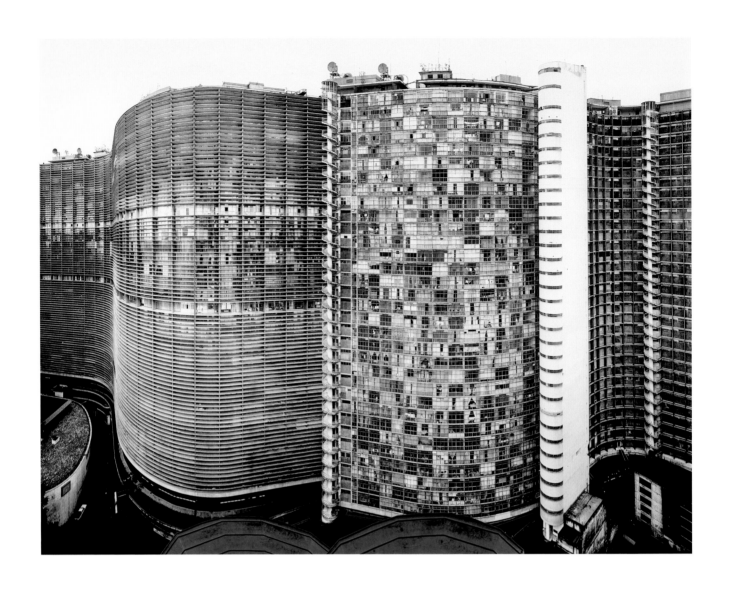

fig. 16 Andreas Gursky (German, born 1955), *Copan*, 2002. Chromogenic print. Courtesy Gagosian. © 2018 Andreas Gursky/ Artists Rights Society (ARS), New York/ VG Bild-Kunst, Bonn/ Courtesy Sprüth Magers Berlin London.

photographic collage as an offhand homage to the quotidian nature and quirks of the Southern California street scene. Bernd and Hilla Becher, throughout their long and influential careers, presented rigorously conceived grids of deadpan photographs of similar "anonymous" structures, to underscore the nature of their similarities rather than laud their distinctiveness (fig. 15).

If modernist architects of the 1920s "took for granted that the mission of architecture was to improve the human condition,"[26] what is striking about the works of many late-twentieth-century and twenty-first-century artists whose images of the built world have become iconic is that rather than being celebratory, they look at architecture as symptomatic or as a reflection of the world's complications, not as the solution to them. As Andreas Gursky expressed it:

> Space is very important for me but in a more abstract way. Maybe to try to understand not just that we are living in a certain building or in a certain location, but to become aware that we are living on a planet that is going at enormous speed through the universe. I read a picture not for what's really going on there, I read it more for what is going on in our world generally (fig. 16).[27]

Among the things that are "going on in our world generally" are radical changes in the way images are made, circulated, used, and understood, especially in light of digital technology's reengineering and further democratization of photography. "The appetite for architecture today . . . must in reality be an appetite for something else. I think it is an appetite for photography," the cultural critic Fredric Jameson wrote in 1991.[28] A quarter of a century later, the hunger for—as well as the making, sharing, and display of—architectural imagery has only intensified. Google Street View picks up where Ed Ruscha left off, by documenting streets in towns and cities around the world and each of the buildings that line them (fig. 17). The temporary fences that surround construction sites are routinely wrapped in all-weather, idealized Photoshopped renderings of edifices on the rise. Developers of high-rises launch drones to capture panoramic images shot from the exact height of upper-floor windows in order to impress prospective buyers or renters.[29] On Pinterest, users collect the sorts of architectural images that appeal to them, and display them with fervor. Websites

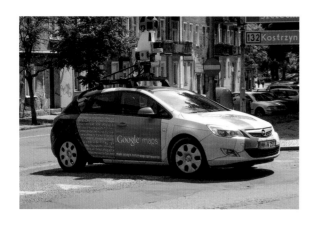

such as Curbed, ArchDaily, and Architizer research and report on the top architects to follow on Instagram.

As Marc Kushner, Architizer's cofounder, sees it, "Instagram, Facebook, and Twitter are fomenting the biggest revolution in architecture since the invention of steel, concrete, and the elevator." Architectural photography is, as a result, now produced as avidly by the public as it is by specialized professional image-makers. "Today," Kushner has also said, "every single person who lays eyes on a building can be at once a user, an architectural photographer, and a critic with a public forum—even if that criticism is simply 'I luv that' or 'check me out I am in Seattle'" (fig. 18).[30]

In fact, so many near-identical photos of iconic structures—like Seattle's Space Needle or its public library designed by Rem Koolhaas and Joshua Prince-Ramus—have been taken that some visual culture observers wonder what motivates people to make more. One of them, Philipp Schmitt, a German designer, in 2015 developed the prototype for the Camera Restricta, a digital camera with GPS and Internet connectivity that, if its user stood within 115 feet of a site where more than thirty-five similar photographs had already been made and posted to Flickr, would refuse to take another one.[31]

But the fact is that we all "make intense emotional investments in certain buildings and structures," as the critic John Yau wrote in an essay on Hiroshi Sugimoto's haunting soft-focus architectural photographs. "One cannot separate the Eiffel Tower from Paris, for example. . . . We regard these structures as living symbols, as structures so potent in our imagination that we think of them as possessing a life force" (fig. 19).[32]

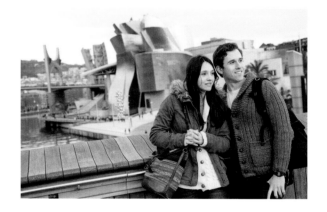

fig. 17 Google Street View camera car in Gorzów, Poland. Photograph by Staszek.

fig. 18 Young couple visiting the city, Guggenheim Museum, Abandoibarra, Bilbao, Bizkaia, Basque Country, Spain. Photograph by age fotostock/ Alamy Stock Photo.

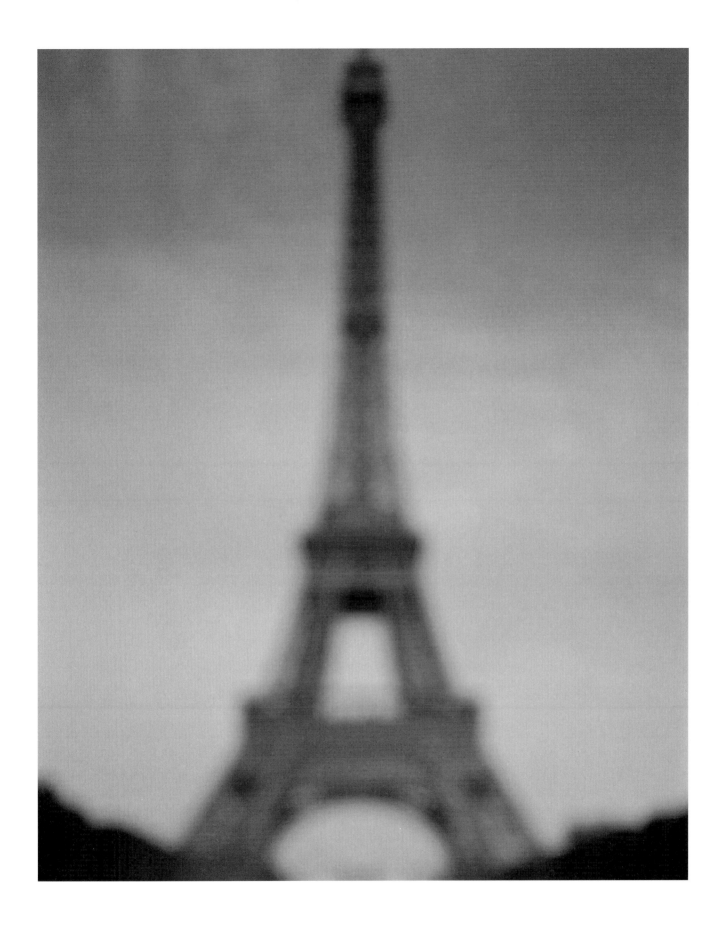

fig. 19 Hiroshi Sugimoto (Japanese, born 1948), *Eiffel Tower,* 1998.
Gelatin silver print. Courtesy Fraenkel Gallery, San Fransico. © 2018
Hiroshi Sugimoto.

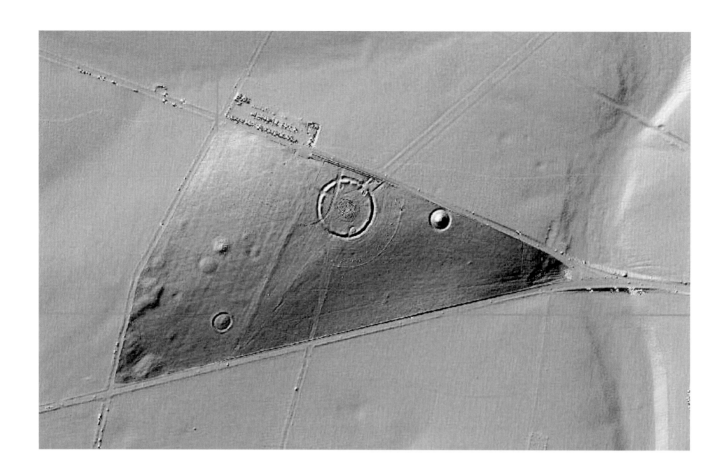

It is important as well to acknowledge how photography is now being called into service to recapture the "life force" of buildings that are no longer standing or have vanished from sight. In 2016, months after ISIS rebels destroyed the ancient Arch of Triumph in Palmyra, a World Heritage site in Syria, a two-third-scale replica of it, modeled from preexisting 3-D photographs and scans, was exhibited first in London's Trafalgar Square and then in New York's City Hall Park, blocks from the World Trade Center site.[33] Aerial images produced with computational photographic tools like LIDAR (Light Detection and Ranging)—employing lasers to scan and reveal what lies buried underground at ancient sites like Stonehenge, and medieval ones like Phnom Penh in Cambodia—help us see structures lost to time (fig. 20).[34]

What these technologically advanced uses of imaging and the compelling works featured in this book suggest is that even as architecture and photography evolve independently, they remain intertwined. Buildings are complex in their conception, construction, and

fig. 20 LIDAR (Light Detection and Ranging) view of Stonehenge.
Courtesy English Heritage, UK.

functionality. So do photographs made of them that reach multiple audiences and, once they do, live multiple lives. That the rise and fall of buildings are well represented in photographs that, despite their apparent permanence, are also vulnerable is noteworthy and ironic. Negatives rest atop fragile film emulsions. Photographic prints and reproductions tear and fade and age. Images made and stored digitally are susceptible to data loss. What we marvel at and value in architectural photography, though, is not necessarily materiality, but its unique and powerful iconicity. What fascinates us is how fragile images—which often long outlive the structures of steel, stone, brick, concrete, and wood that are their subjects—can be enduring symbols of stability. They become the sometimes proud, sometimes poignant markers of our experiences in the built environment, our myriad endeavors to challenge time.

1 David Friend, *Watching the World Change: The Stories Behind the Images of 9/11* (New York: Farrar, Straus and Giroux, 2006), p. 36.

2 Quoted in James S. Ackerman, "On the Origins of Architectural Photography" (2001), in *This is Not Architecture: Media Constructions*, ed. Kester Rattenbury (London and New York: Routledge, 2006), p. 26.

3 See Shelley Rice, *Parisian Views* (Cambridge, MA, and London: The MIT Press, 1999).

4 Reverend F. F. Stratham, "On the Application of Photography on Scientific Pursuits," paper read at a meeting of the South London Photographic Society, published in *Photographic Notes*, August 1, 1860, p. 210, https://books.google.com/books?id=ZMAaAAAAYAAJ&p-g=PA208&lpg=PA208&dq=Photo-graphic+Notes:+The+application+of+-photography+to+scientific+pur-suits.+1860&source=bl&ots=eWs90Qn-oRk&sig=2GA6Dbn_3zttU2CFXpoB-9Mh88c&hl=en&sa=X&ved=0ahUKEw-jroNz10KXNAhXLPz4KHd0OCK8Q6AEII-TAB#v=onepage&q=Photographic%20Notes%3A%20The%20applica-tion%20of%20photography%20to%20scientific%20pursuits.%201860&f=false.

5 Donald Albrecht, *The Mythic City: Photographs of New York by Samuel H. Gottscho, 1925–1940* (New York: Princeton Architectural Press, 2005), p. 28.

6 Nathalie Hershdorfer and Lada Umstätter, "Making Images," in *Le Corbusier and the Power of Photography*, ed. Nathalie Hershdorfer and Lada Umstätter (London and New York: Thames & Hudson, 2012), p. 20.

7 Akiko Busch, *The Photography of Architecture: Twelve Views* (New York: Van Nostrand Reinhold, 1987), p. 6.

8 Richard Pare, *Photography and Architecture: 1839–1939* (Montreal: Canadian Centre for Architecture, and New York: Callaway Editions, 1982), p. 25.

9 Albrecht, *The Mythic City*, p. 28.

10 Quoted in David Campany, "Architecture as Photography: Document, Publicity, Commentary, Art," in *Constructing Worlds: Photography and Architecture in the Modern Age* (London: Barbican Gallery and Prestel, 2014), consulted at http://davidcampany.com/architec-ture-as-photography-document-pub-licity-commentary/.

11 Quoted in Robert Campbell, "Ezra Stoller, 89; His Photos Influenced Modern Designs," *The Boston Globe*, November 3, 2004.

12 Pare, *Photography and Architecture: 1839–1939*, p. 12.

13 Walter Benjamin, "The Author as Producer" (1934), in *Understanding Brecht*, trans. Ann Bostock (London and New York: Verso, 1998), p. 94.

14 Jean-Pierre Greff and Elisabeth Milon, "Interview with Lewis Baltz—Photography Is a Political Technology of the Gaze" (1993), American Suburb X, March 11, 2011, http://www.americansuburbx.com/2011/03/interview-interview-with-lewis-baltz.html.

15 Walter Benjamin, "The Work of Art in the Age of Mechanical Reproduction" (1936), in *Illuminations: Essays and Reflections*, ed. Hannah Arendt, trans. Harry Zohn (New York: Schocken, 2007), pp. 217–51.

16 Greff and Milon, "Interview with Lewis Baltz."

17 Charles S. Peirce, "What Is a Sign?" (ca. 1894), in *The Essential Peirce: Selected Philosophical Writings*, vol. 2 *(1893–1913)*, ed. Peirce Edition Project (Bloomington and Indianapolis: Indiana University Press, 1998), pp. 4–11.

18 Quoted in Eeva-Liisa Pelkonen, "The Search for (Communicative) Form," in *Eero Saarinen: Shaping the Future*, ed. Eeva-Liisa Pelkonen and Donald Albrecht (New Haven and London: Yale University Press, in association with others, 2007), p. 93.

19 Julius Shulman, oral history interview with Taina Rikala De Noriega [Noriega], January 12–February 3, 1990, for the Archives of American Art, http://www.aaa.si.edu/collections/interviews/oral-histo-ry-interview-julius-shulman-11964.

20 Albrecht, *The Mythic City*, p. 27.

21 Pelkonen and Albrecht, intro-duction to *Eero Saarinen: Shaping the Future*, p. 3.

22 Shulman, oral history interview.

23 Quoted in Fred A. Bernstein, "How Iwan Baan Became the Most Wanted Photographer in Architecture," *The Wall Street Journal*, April 3, 2014, http://www.wsj.com/articles/SB10001424052702303563304579445540585409618.

24 Quoted in *Sherin Wing, "The Indicator: Iwan Baan . . . On Photography,"* ArchDaily, July 14, 2011, http://www.archdaily.com/150393/the-indica-tor-iwan-baan%25e2%2580%25a-6on-photography/.

25 Iwan Baan, "Ingenious Homes in Unexpected Places," TED Talk, September 2013, http://www.ted.com/talks/iwan_baan_ingenious_homes_in_unexpected_places?lan-guage=en.

26 Michael J. Lewis, "How Art Became Irrelevant: A Chronological Survey of the Demise of Art," *Commentary*, July 1, 2015, https://www.commentarymagazine.com/article/how-art-became-irrelevant/.

27 Press release for *Andreas Gursky* (March 4–May 1, 2010), Gagosian, 2010, https://www.gagosian.com/exhibitions/march-04-2010--andreas-gursky.

28 Quoted in Campany, "Architecture as Photography: Document, Publicity, Commentary, Art."

29 Robin Finn, "The Stratospherians," *The New York Times*, May 12, 2013, http://www.nytimes.com/2013/05/12/realestate/paying-a-premium-for-sky-high-apartments.html.

30 Marc Kushner, "A New Golden Age of Architecture," Architizer, March 10, 2015, https://medium.com/@march-itizer/a-new-golden-age-of-architec-ture-825fb7ed652c#.yejhlkih0.

31 Liz Stinson, "This Camera Won't Let You Take the Photo Everyone Else Does," *Wired*, September 14, 2015, https://www.wired.com/2015/09/camera-wont-let-take-photo-every-one-else/.

32 John Yau, "The Dissolving World," in Francesco Bonami, Marco De Michelis, and John Yau, *Sugimoto: Architecture* (Chicago: Museum of Contemporary Art, 2003), p. 21.

33 Claire Voon, "Slick Replica of Palmyra's Triumphal Arch Arrives in New York, Prompting Questions," Hyperallergic, September 20, 2016, http://hyperallergic.com/323978/slick-replica-of-palmyras-triumphal-arch-arrives-in-new-york-prompting-questions/.

34 "7 New Discoveries About Stonehenge," *Heritage Calling: A Historic England Blog*, September 23, 2015, https://heritagecalling.com/2015/09/23/7-new-discover-ies-about-stonehenge/.

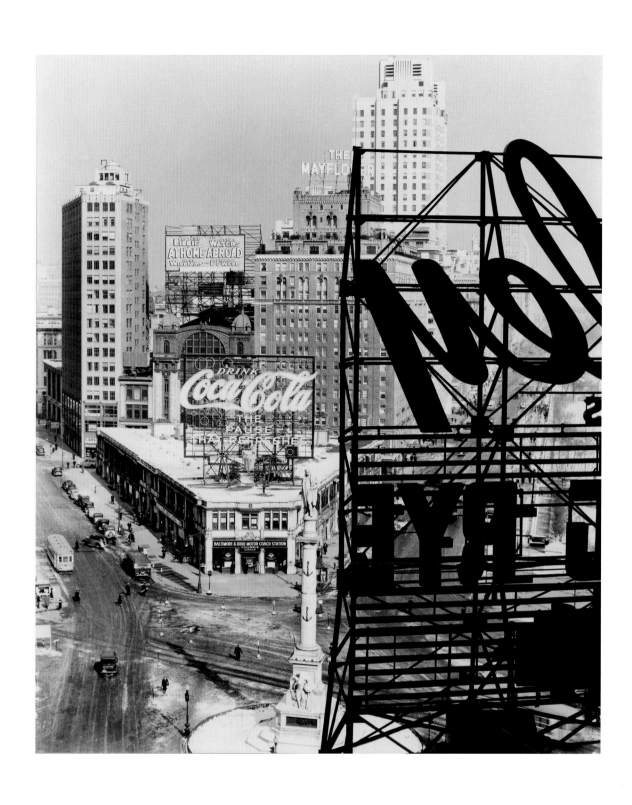

PLATE 3 BERENICE ABBOTT (AMERICAN, 1898–1991), *CHANGING NEW YORK; COLUMBUS CIRCLE*, 1936

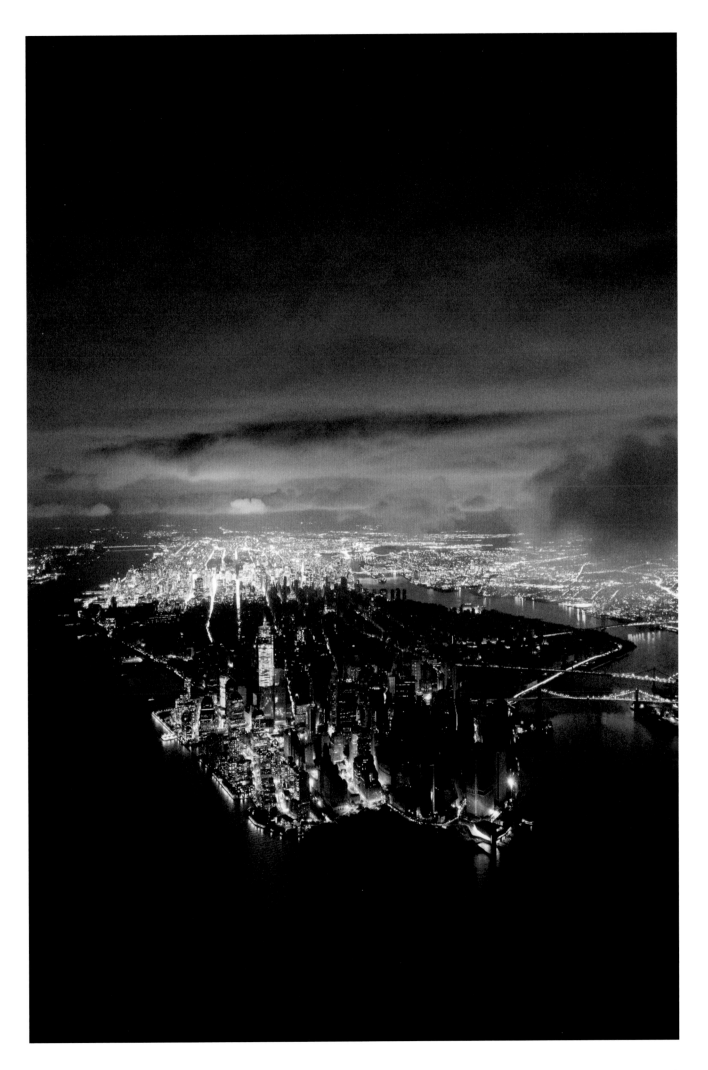

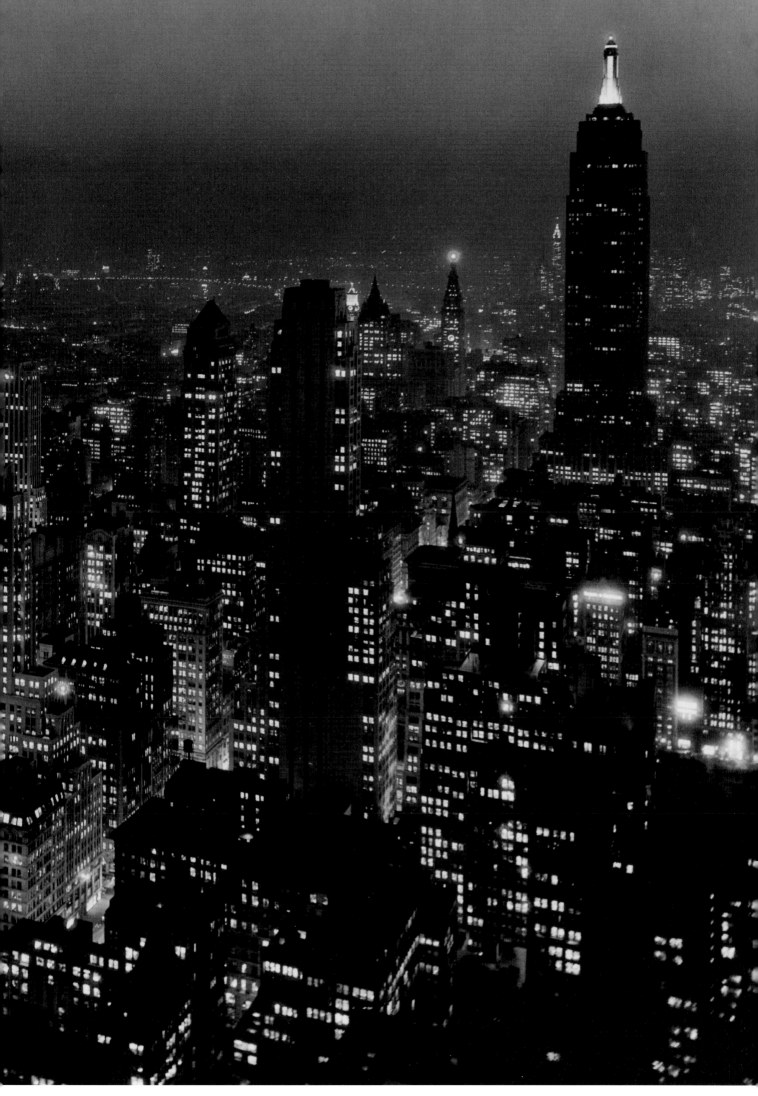

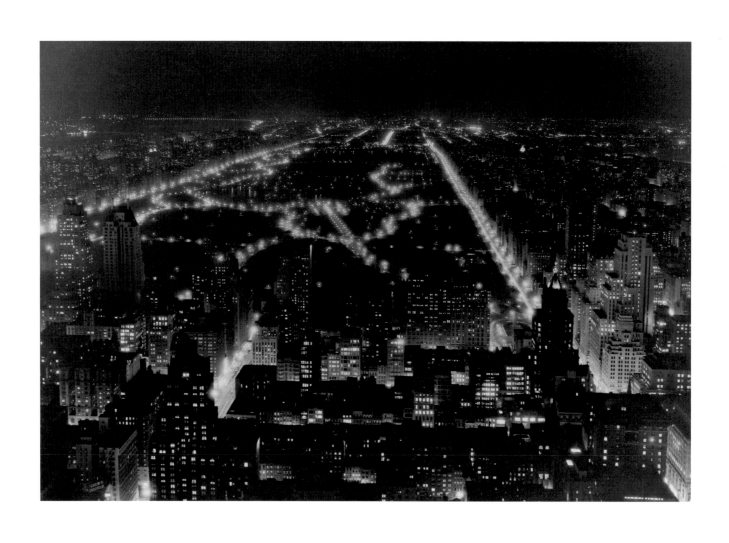

[PREVIOS SPREAD] PLATE 5 SAMUEL H. GOTTSCHO (AMERICAN, 1875–1971), *SOUTHEAST FROM THE RCA BUILDING* [ROCKEFELLER CENTER], 1934

PLATE 6 SAMUEL H. GOTTSCHO (AMERICAN, 1875–1971), *NORTH FROM THE RCA BUILDING* [ROCKEFELLER CENTER], 1934

Architecture After Photography

THERESE LICHTENSTEIN

Photography is not about the thing photographed. It is about how that thing looks photographed. GARRY WINOGRAND

In Samuel H. Gottscho's and Berenice Abbott's nocturnal aerial views of New York from the 1930s, lights glow from inside skyscrapers, sparkling like stars against the dark city sky (pls. 2, p. 25; 5, p. 44–45; 6, p. 46). Photographed during the Depression, these images brim with wonder and exhilaration, celebrating the power of new building technologies and the "heroic materialism" of the modern city.[1] The grit of urban life is invisible, and people are nowhere to be seen. The photographs capture a time when American optimism coexisted with economic struggle, when Hollywood fantasy offered hope and temporary escape from bleak everyday reality. Gottscho (1875–1971) produced his magical effects by combining two exposures into a composite image, as seen in a number of images of the RCA Building: "The first exposure was made at dusk to register the building's ziggurat silhouette against the darkening sky; the second, from the exact same spot but with a longer exposure time, was made later to capture the building's windows blazing with artificial illumination."[2] Gottscho's and Abbott's images beautifully summon a mythic and potent old New York.

Eight decades later, another photographer produced aerial photographs of New York at night to markedly different effect. On October 31, 2012, two days after Hurricane Sandy cataclysmically hit New York, knocking out power in lower Manhattan, Iwan Baan (b. 1975), a Dutch architectural photographer, took a series of dramatic panoramic views from a helicopter. One illustrated the cover of *New York* magazine under the title "The City and the Storm"[3] (pl. 4, p. 43). This startling image powerfully contrasts the light and dark areas, the haves and have-nots. In the foreground, the Goldman Sachs Tower and the then partially constructed One World Trade Center are among the few buildings

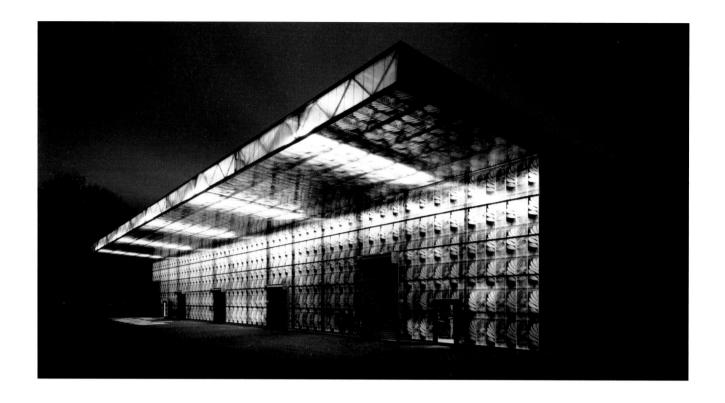

in lower Manhattan that remain lit. Baan reflected: "I think perhaps this 'division of [electric] power' is an allegory for the country's declining infrastructure, telling us also about who is truly prepared for when sobering events like Sandy strike."[4] Baan used cutting-edge technology, a Canon ID X camera with a 24–70mm lens on full open aperture; it was set at 25,000 ISO, with a shutter speed of 1/40 of a second. It would have been impossible for him to capture these images, taken from a moving helicopter vibrating wildly above the city, without this highly sensitive camera.

In such ways, a photographer's aesthetic choices and use of technology can imbue seemingly static buildings with feeling and/ or meaning. As the work of Gottscho, Abbott, and Baan makes clear, photographs help construct and define a place and period from a particular perspective. Through photography—including that in newspapers and magazines and, increasingly, via electronic media—we can see buildings and places we may never visit, and "revisit" places we have actually been.

Photographs can also lend the imprimatur of "art" to architecture. Imaging has become central to architectural practice, as architects

fig. 21 Thomas Ruff (German, born 1958), *Ricola, Mulhouse*, 1994. Chromogenic print, 74 × 112 inches. Courtesy David Zwirner, New York/ London. © 2018 Thomas Ruff/ Artists Rights Society (ARS), New York / VG Bild-Kunst, Bonn.

consider how their work will look in photographs in addition to how it will be constructed, function, and be experienced. In the early 1990s, the Swiss architecture firm Herzog & de Meuron commissioned Thomas Ruff (b. 1958) to photograph its buildings to gain his perspective on them and to see what they would look like as art. Ruff is among the contemporary photographers who use digital manipulation (of either archival images or, more often, his own "straight" architectural photographs) to render unusual views of often familiar buildings. As he put it: "I want to break down the clichés and assemble new pictures out of them."[5] His approach is candidly subjective: "The difference between my predecessors and me is that they believed to have captured reality and I believe to have created a picture."[6]

In 1991, Ruff produced a photograph of the Ricola Storage Building in Laufen, Switzerland, which Herzog & de Meuron designed and completed in 1986–1987, by splicing together and retouching two photographs of the building by another photographer.[7] Three years later, Ruff combined digital manipulation with his own photography of the firm's 1993 Ricola-Europe Production and Storage Building in Mulhouse-Brunstatt, France. The violet-hued photographs that resulted from his electronic retouching (fig. 21) highlight the sculptural reliefs on the outside of the building, which were inspired by botanical motifs in early-twentieth-century photographs by Karl Blossfeldt and the natural ingredients in Ricola's products.[8]

In 1999–2000, Ruff created a series of photographs in conjunction with an exhibition celebrating the restoration of two of Ludwig Mies van der Rohe's early-twentieth-century modernist buildings, Haus Lange and Haus Esters, in Krefeld, Germany. He expanded the scope of the project to include two other Mies buildings of similar vintage, the Villa Tugendhat in Brno, Czech Republic, and the Barcelona Pavilion in Spain (pl. 7, p. 52). (Built as a temporary structure for the German Pavilion in Spain at the 1929 International Exposition, the Barcelona Pavilion was destroyed at the end of the exposition and reconstructed between 1983 and 1986. The original building is seen only in drawings and photographs.) He made multiple reproductions of the same "straight" photograph and digitally changed the color and focus of each, defamiliarizing the familiar by presenting these iconic modernist buildings in altered states. In one image (pl. 8, p. 53) an out-of-focus

building, set on a diagonal against an artificially tinted blue-green sky, appears like a fleeting memory or a glimpse through the window of a fast-moving train; it suggests movement, speed (associated with modernity), and passing time.[9] (This building was one of twenty-one buildings on the Weissenhof Estate. The complex was built for the Stuttgart Werkbund Exhibition in 1927, and represented a model for affordable housing during a time of housing shortages. The buildings in the complex were designed by various architects and showcased the International Style of architecture.) After viewing Ruff's photographs, we see Mies's buildings and documentary images of them in a new light. The original building disappears in its documentary reproduction, and its documentary reproduction disappears in the manipulated digital one. Ruff draws attention to photography's power to influence and challenge our perceptions.

The work of Japanese photographer and architect Hiroshi Sugimoto (b. 1948) shares some themes with Ruff's—history, time, perception, transience—but their techniques, forms, and moods differ. Sugimoto's photographic manipulation is analogue, not digital: he often places his nineteenth-century-style eight-by-ten-inch camera in front of buildings and photographs them with long exposure times to obtain various tonal depths and to convey the passage of time (pl. 10, p. 55).

Sugimoto's photographs are subjective interpretations and projections of his creative invention: "I imagine my vision then try to make it happen, just like painting. The reality is there, but how to make it like my reality."[10] The result is rich, dark, hallucinatory photographs that are as arresting and as seemingly real as a dream that lingers long after waking. In Sugimoto's hauntingly blurry but recognizable images, solid architecture seems weightless, as though made of light and shadow. Indeed, Jun'ichiro Tanizaki's book *In Praise of Shadows* (1933), an essay on Japanese aesthetics, was an important source of inspiration for Sugimoto. Tanizaki writes: "The beauty of a Japanese room depends on a variation of shadows, heavy shadows against light shadows—it has nothing else."[11]

Sugimoto commented on his process in creating a series of photographs of significant modernist architecture from around the world, commissioned by the Museum of Contemporary Art in Los Angeles in 1997: "I decided to trace the beginnings of our age via architecture.

Pushing my old large-format camera's focal length out to twice-infinity—with no stops on the bellows rail, the view through the lens was an utter blur—I discovered that superlative architecture survives, however dissolved, the onslaught of blurred photography. Thus I began erosion-testing architecture for durability, completely melting away many of the buildings in the process."[12] Sugimoto described this series as "architecture after the end of the world."[13] His images function as memento mori, reflections on the passage of time, impermanence, and mortality. If such musings on the entropy and eventual demise of landmark buildings are poignant, there is comfort in these images, both in their beauty and in their preservation of the buildings, in photographic form, at least.

Some of the early to mid-century modernist buildings Sugimoto photographed in the late 1990s and the 2000s had been photographed half a century earlier by a generation of commercial photographers, among them Ezra Stoller, Balthazar Korab, Julius Shulman, and Samuel Gottscho (pls. 9–10, pp. 54–55; pls. 11–12, pp. 56–57). Both Sugimoto and Stoller (1915–2004) memorably photographed the Seagram Building (375 Park Avenue, New York), designed by Mies van der Rohe and completed in 1958. Comparing images by the two photographers reveals the objective changes that occur over a span of decades as well as the subjective distinctions between the photographers' styles and interpretations. One of Stoller's early photographs of the building (pl. 18, p. 64) emphasizes its sleek, industrial verticality, especially in contrast with the shorter structures nearby. By the time Sugimoto photographed it, almost forty years later, the Seagram Building was hemmed in by skyscrapers, including the Citicorp Building that had risen around it[14] (pl. 20, p. 67). Where Sugimoto's photograph is a meditation on inevitable change, making us consider what was, is, and will be, Stoller's heroic, stable vision of the modernist icon celebrates the new. Stoller's images of the TWA terminal at John F. Kennedy International Airport glorify architect Eero Saarinen's majestic futuristic design. The building, constructed between 1956 and 1962, suggests a huge bird that either is about to ascend or has just landed. One of Stoller's predawn

continued on page 82

PLATE 7 THOMAS RUFF (GERMAN, BORN 1958), *D.P.B. 02*, 1999

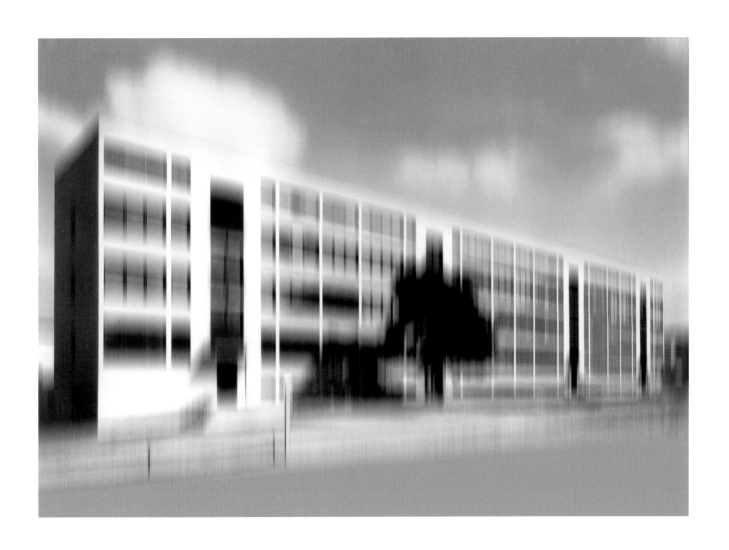

PLATE 8 THOMAS RUFF (GERMAN, BORN 1958), *W.H.S. 10*, 2001

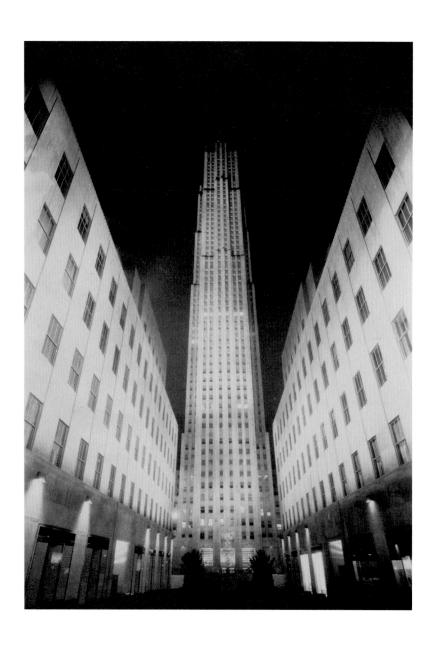

PLATE 9 SAMUEL H. GOTTSCHO (AMERICAN, 1875–1971), *NEW YORK CITY VIEWS, RCA BUILDING FLOODLIGHTED*, 1933

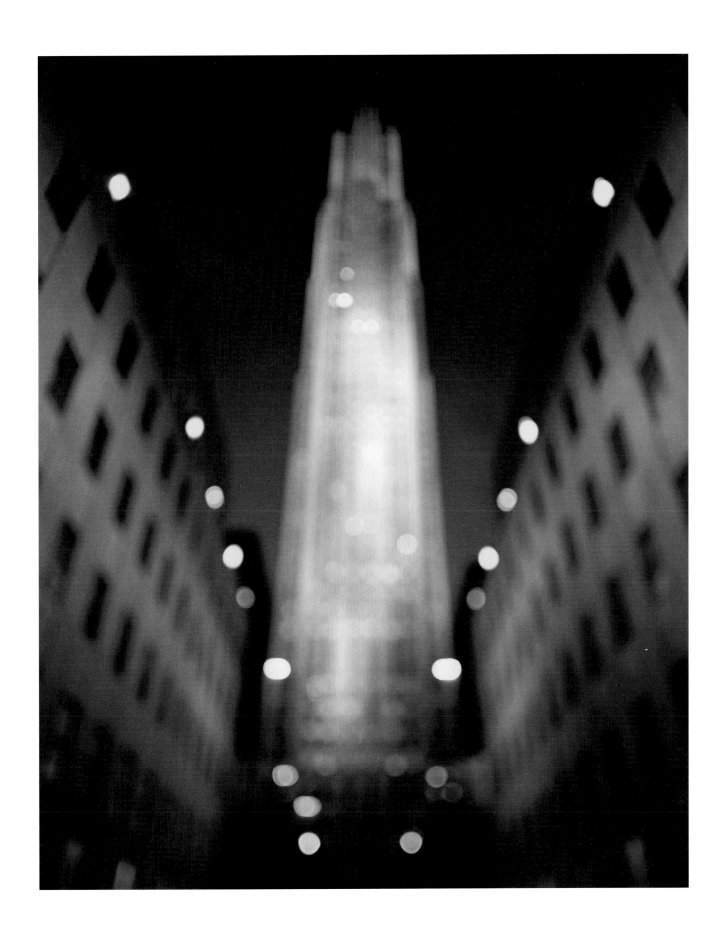

PLATE 10 HIROSHI SUGIMOTO (JAPANESE, BORN 1948), *ROCKEFELLER CENTER*, 2001

PLATE 11 EZRA STOLLER (AMERICAN, 1915–2004), *NOTRE DAME DU HAUT, RONCHAMP CHAPEL, LE CORBUSIER, RONCHAMP, FRANCE*, 1955

PLATE 12 HIROSHI SUGIMOTO (JAPANESE, BORN 1948), *CHAPEL OF NOTRE DAME DU HAUT*, 1998

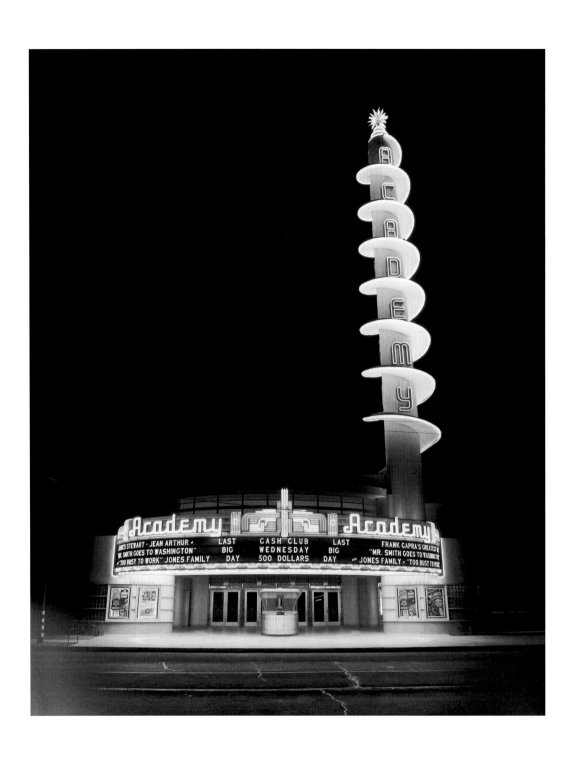

PLATE 13 JULIUS SHULMAN (AMERICAN, 1910–2009), *ACADEMY THEATER, EXTERIOR (INGLEWOOD, CALIF.)*, 1940

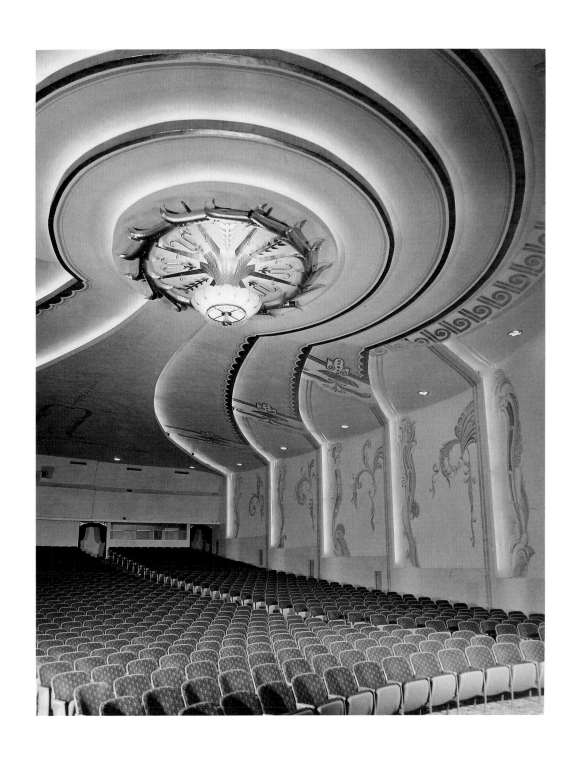

PLATE 14 JULIUS SHULMAN (AMERICAN, 1910–2009), *ACADEMY THEATER, INTERIOR (INGLEWOOD, CALIF.)*, 1940

PLATE 15 HIROSHI SUGIMOTO (JAPANESE, BORN 1948), *RADIO CITY MUSIC HALL, NEW YORK*, 1978

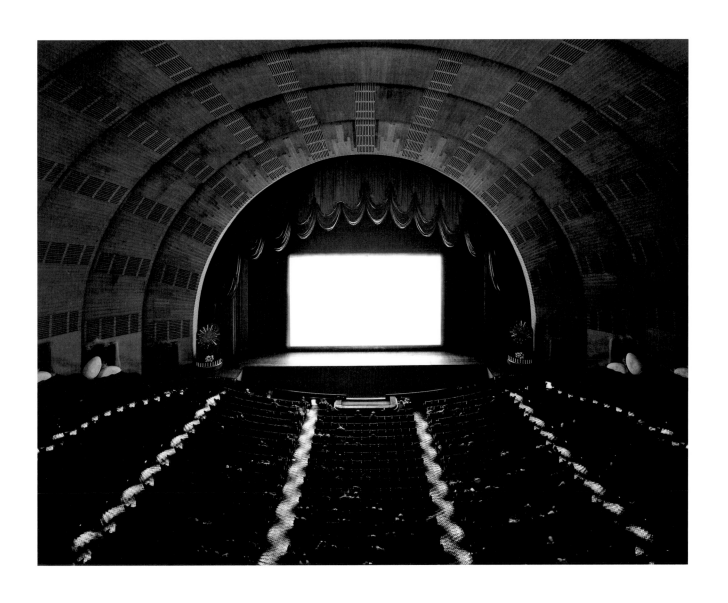

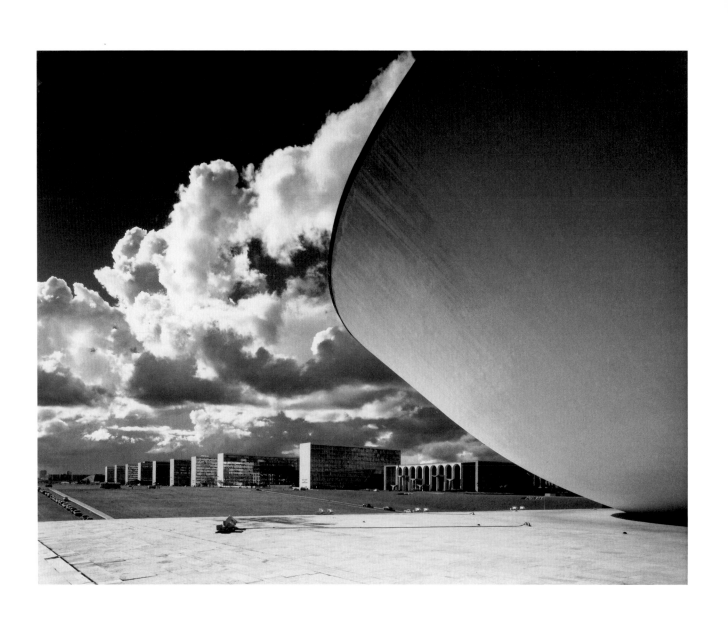

PLATE 16 JULIUS SHULMAN (AMERICAN, 1910–2009), *BRASÍLIA BUILDINGS (BRASÍLIA, BRAZIL)*, 1977

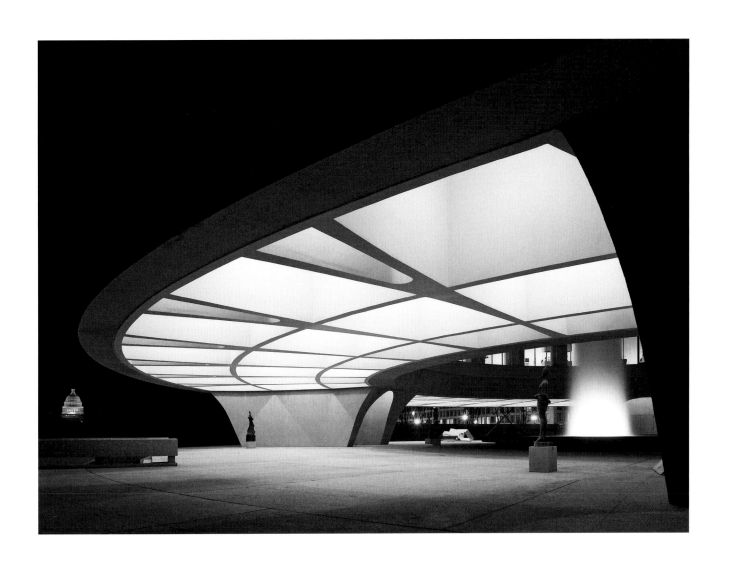

PLATE 17 EZRA STOLLER (AMERICAN, 1915–2004), *HIRSHHORN MUSEUM, SKIDMORE, OWINGS & MERRILL, WASHINGTON, D.C.,* 1974

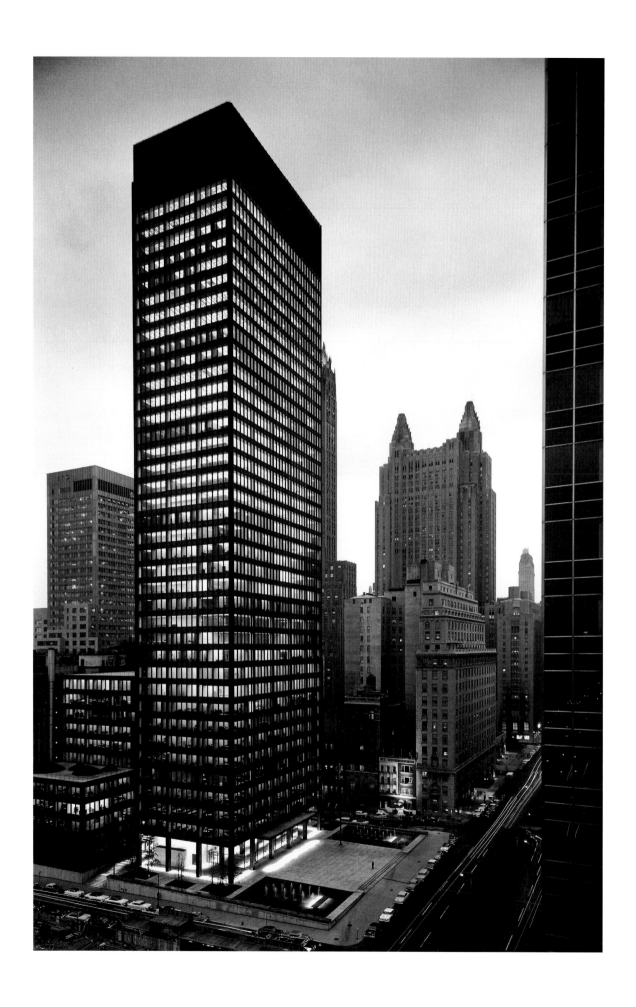

PLATE 18 EZRA STOLLER (AMERICAN, 1915–2004), *SEAGRAM BUILDING, MIES VAN DER ROHE WITH PHILIP JOHNSON, NEW YORK, NY, 1958*

PLATE 19 EZRA STOLLER (AMERICAN, 1915–2004), *JOHNSON WAX ADMINISTRATION BUILDING AND RESEARCH TOWER, FRANK LLOYD WRIGHT, RACINE, WI, 1950*

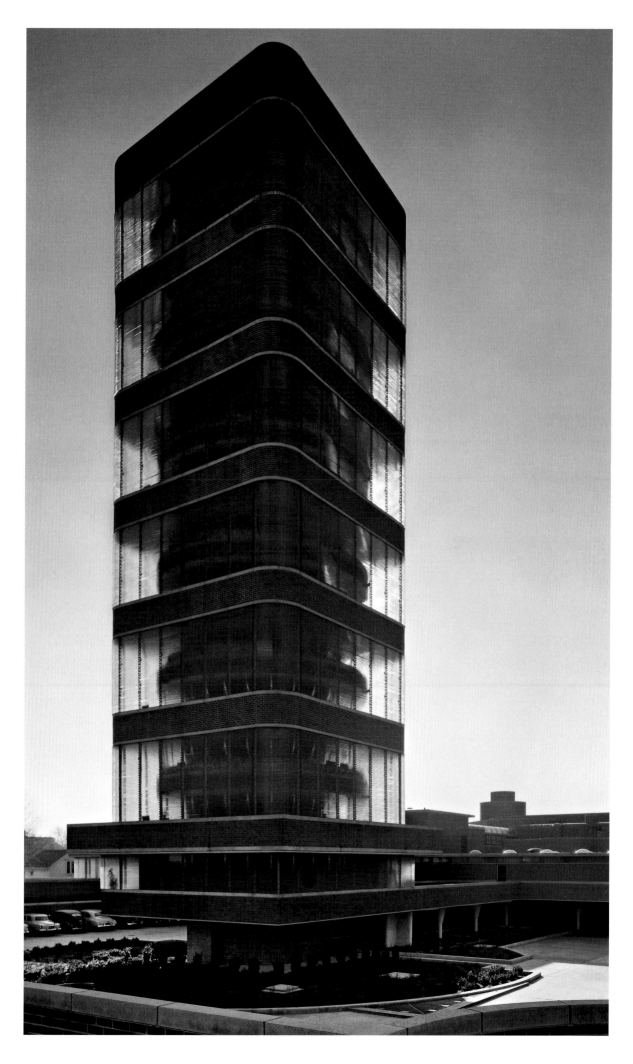

PLATE 20 HIROSHI SUGIMOTO (JAPANESE, BORN 1948), *SEAGRAM BUILDING*, 1997

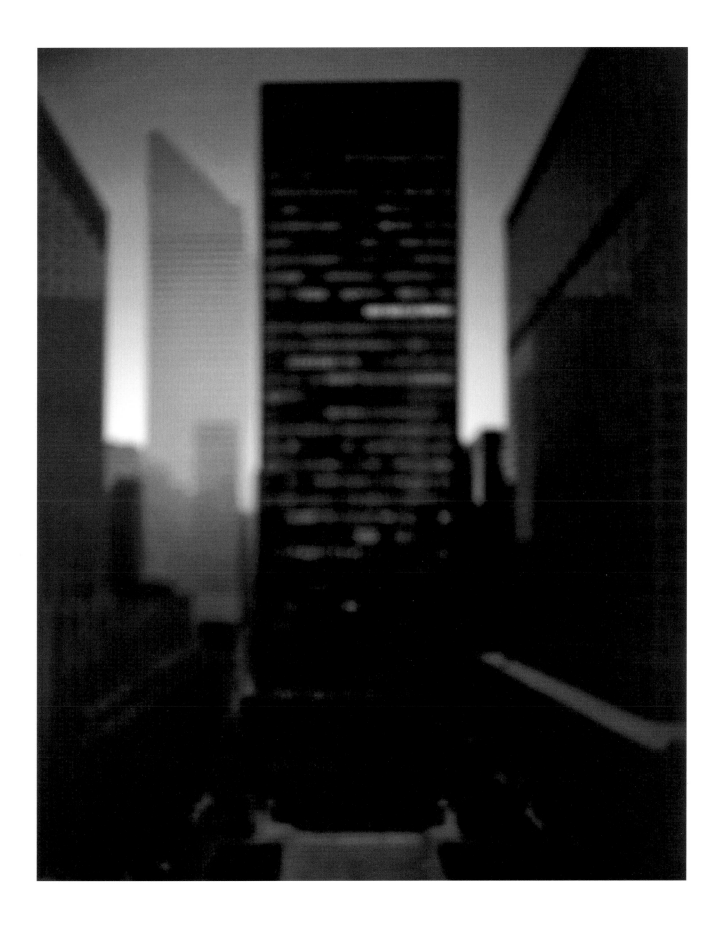

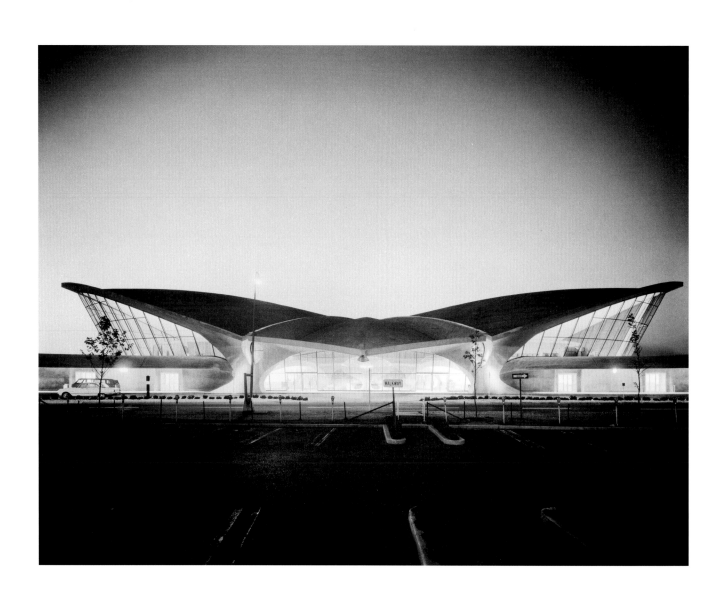

PLATE 21 EZRA STOLLER (AMERICAN, 1915–2004), *TWA TERMINAL AT IDLEWILD (NOW JFK) AIRPORT, EERO SAARINEN, NEW YORK, NY,* 1962

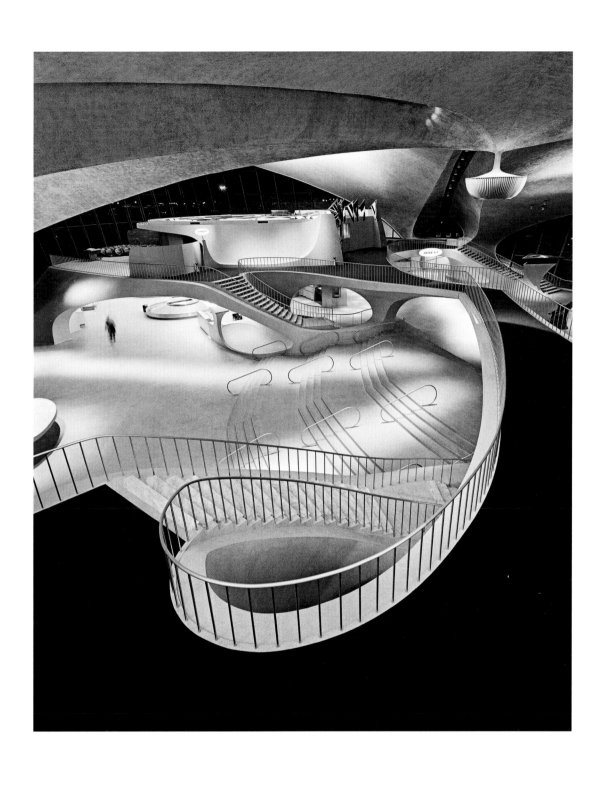

PLATE 22 BALTHAZAR KORAB (HUNGARIAN, 1926–2013), *TWA FLIGHT CENTER IN JFK INTERNATIONAL AIRPORT (QUEENS, NEW YORK),* 1964

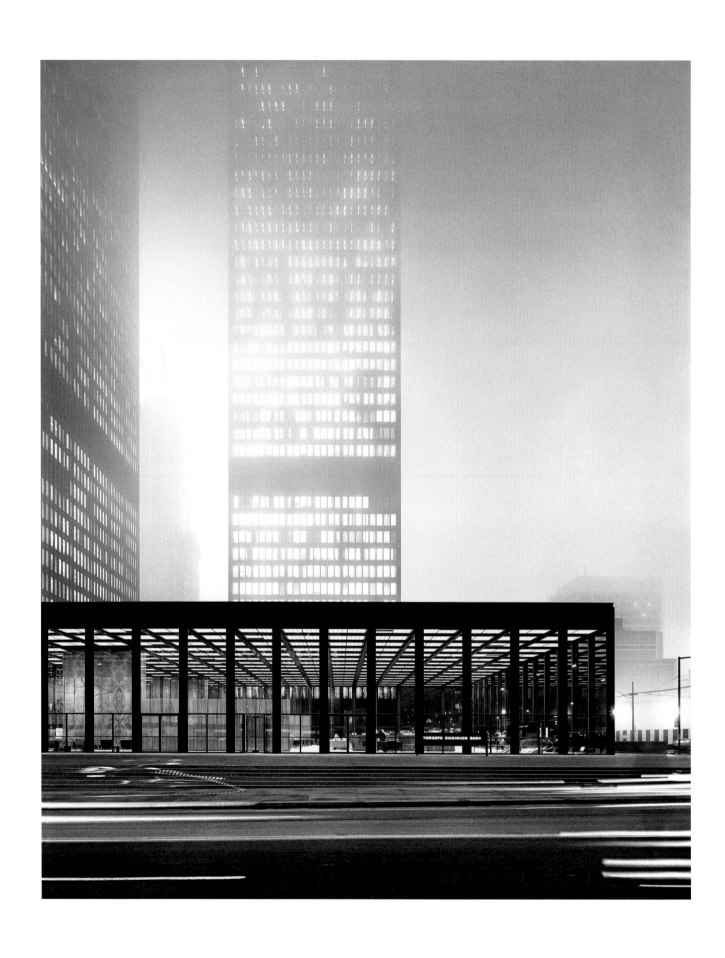

PLATE 23 BALTHAZAR KORAB (HUNGARIAN, 1926–2013), *TORONTO-DOMINION CENTRE*, 1960s

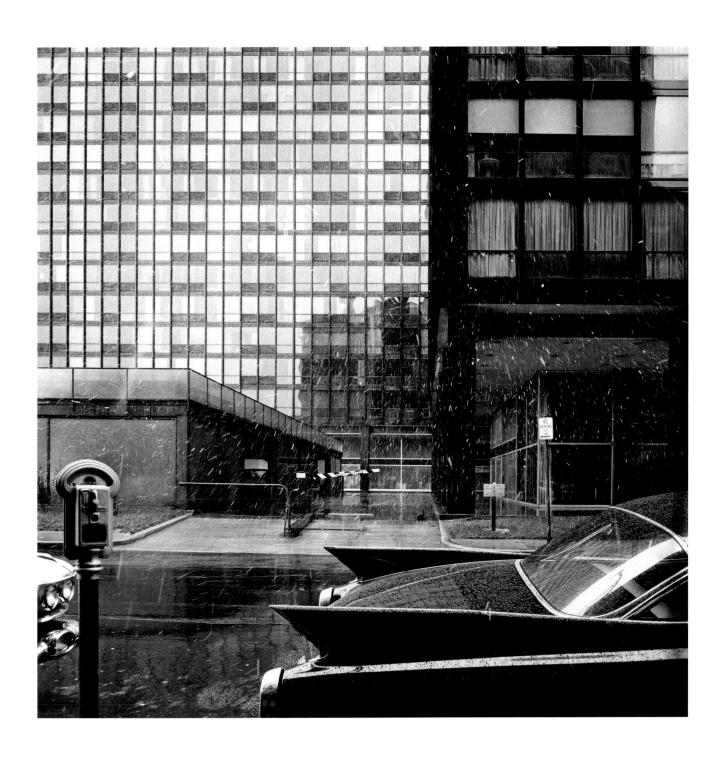

PLATE 24 BALTHAZAR KORAB (HUNGARIAN, 1926–2013), *860–880 LAKE SHORE DRIVE APARTMENTS, CHICAGO, IL*, 1960

PLATE 26 JULIUS SHULMAN (AMERICAN, 1910–2009), *CHUEY HOUSE (LOS ANGELES, CALIF.)*, 1956

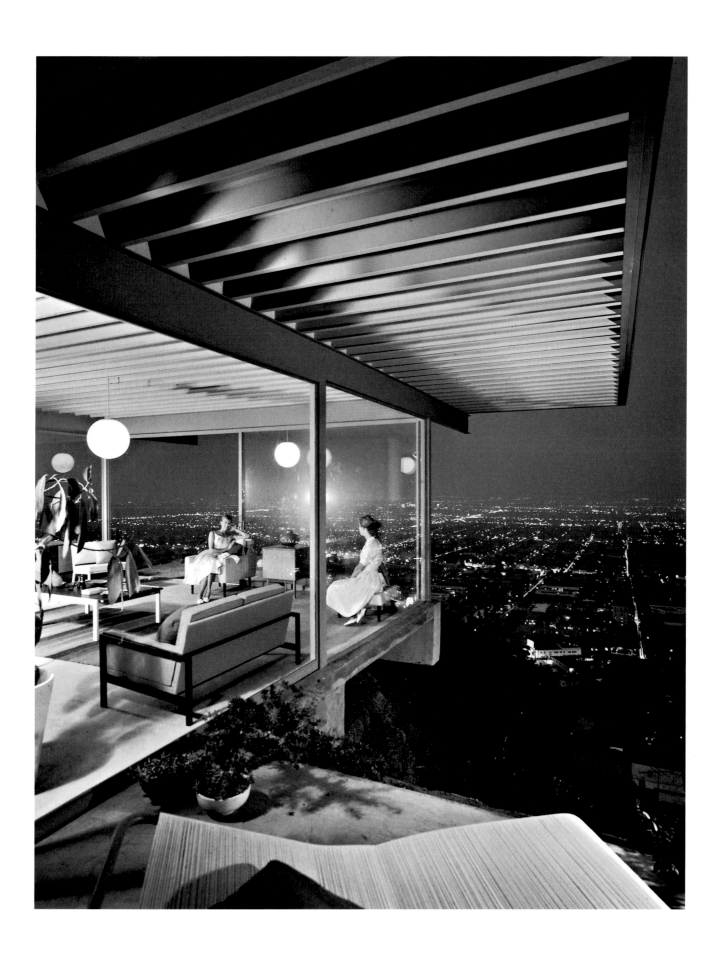

PLATE 27 JULIUS SHULMAN (AMERICAN, 1910–2009), *CASE STUDY HOUSE NO. 22 (LOS ANGELES, CALIF.)*, 1960

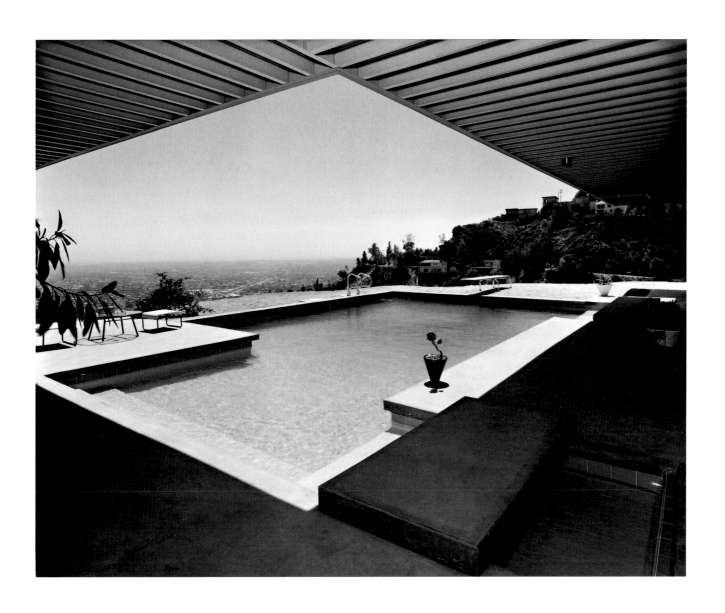

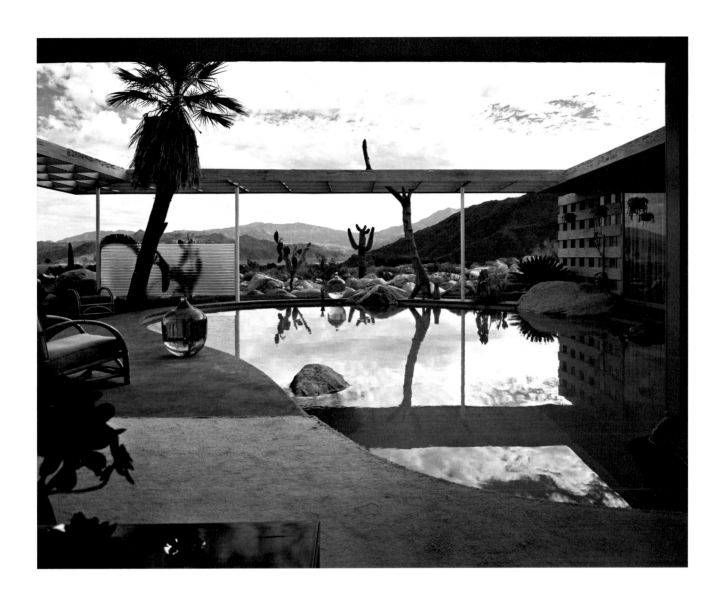

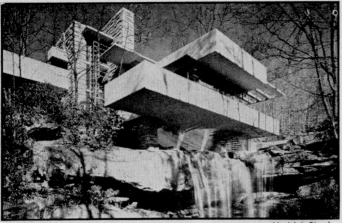

"Falling Water," Frank Lloyd Wright's cantilevered concrete house built for Edgar Kaufmann at Bear Run, Pa.

Architect Pietro Belluschi calls this natural-finish wood ranch house at Yamhill, Ore. his best effort. Cost: $60,000.

MODERN HOUSES...

Like them or not, modern houses are here to stay. Their practicality and sometimes spectacular good looks were foreshadowed by 19th Century bridges and grain elevators, the skyscrapers and banks of Louis Sullivan, and the early works of Wisconsin-born Frank Lloyd Wright, the wild dean of modern architecture.

Half a dozen immigrants, all Europeans, have helped swell the modern U.S. tide: Germany's Walter Gropius and Mies Van Der Rohe, Finland's Eliel Saarinen, Hungary's Marcel Breuer, Italy's Pietro Belluschi and

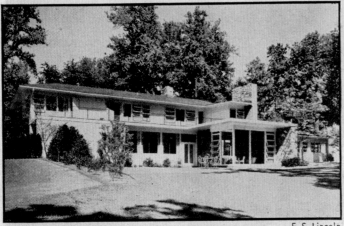

Wurster, Bernardi & Emmons built this Fresno, Calif. house at a cost of $11,402; it features a 17-ft. ceiling.

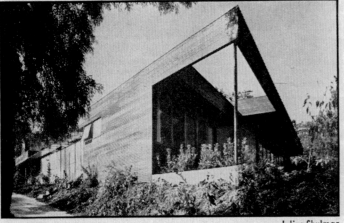

This eight-bedroom Long Island house was built of wood, brick and stone for $125,000. The architect: E. D. Stone.

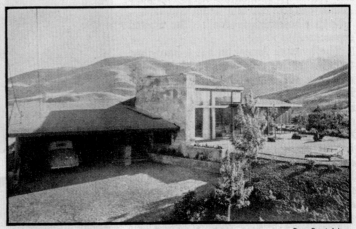

Two whole walls of the living-and-dining room are glass in this $17,000 Fred Langhorst house in Orinda, Calif.

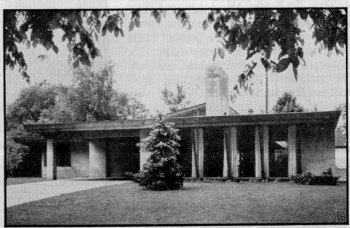

In Los Angeles, Raphael Soriano designed this oiled redwood house, which features a sand-blasted glass fence.

Alden Dow built this Flint, Mich. bungalow for a man who said that he wanted "a lot of room on a low budget."

Marshall Brooks

In Lakewood, Colo, this Victor Hornbein house is bisected by a hearth wall of brick. Built in 1948, it cost $20,000.

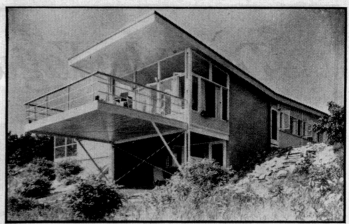

Fred Stone

At Wianno, Mass., famed Walter Gropius' eight-member "Architects' Collaborative" house cost less than $30,000.

...ACROSS THE U.S.A.

Vienna-born Richard Joseph Neutra. Their ideas, still further developed by a third generation, have taken the varied shapes shown on these pages: houses that range in price from well over $100,000 to less than $15,000 and dot the land from coast to coast.

Modern houses still come high, and costs will not diminish much until and unless the squeaky demand grows to a roar. That, as Architect Neutra admits, may take a long long time. "In our profession," he says, "you must be an evangelist as well as an architect."

Bill Johnson—*Daily Oklahoman*

Robert W. Vahlberg's own six-room brick house in Oklahoma City features a solid glass front. It cost $23,000.

Ezra Stoller—Pictorial

In Sarasota County, Fla., this Ralph Twitchell house cost $45,000 in 1948. The owner calls it "The Purple Pelican."

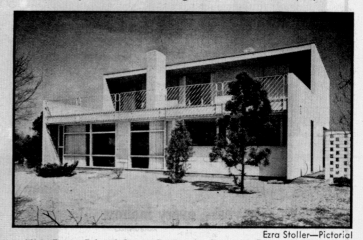

Ezra Stoller—Pictorial

This Long Island frame house, by Marcel Breuer, offers a hanging staircase and a fireplace which faces two ways.

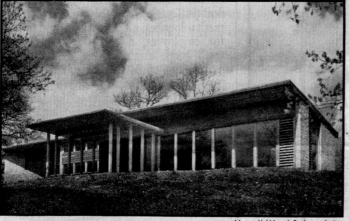

Nowell Ward & Associates

This $26,000 Morgan Yost house in Highland Park, Ill., is ventilated entirely through louvers. The windows stay shut.

Michael Roug.er—LIFE

Bruce Goff's complicated house in Norman, Okla. was built last year for $60,000; it has an indoor flower garden.

photographs of the exterior (pl. 21, p. 68) highlights the terminal's elegant and sensuous curvilinearity. This mysterious, almost eerie photograph presents a dark roof against a dusky sky, with light from a deserted interior shining through large glass walls below. Viewing the image today, we may consider the building's transformation over time. It has been idle since TWA went out of business in 2001, but its landmark status, designated in 1994, preserves it; the terminal was added to the National Register of Historic Places in 2005. The interior is currently being renovated into a luxury hotel and a museum that will feature exhibits on the history of TWA. Once a harbinger of the Jet Age, the building is now its artifact.

Balthazar Korab (1926–2013), a Hungarian architectural photographer based in Detroit, also produced a number of photographs of the TWA terminal.[15] An image of the mezzanine taken at night (pl. 22, p. 69) focuses on the building's biomorphic and otherworldly design. The photograph's subtle tonal variations reveal the texture of the forms, while a small, blurry image of a person moving through the space provides a sense of scale.

Korab's poetic and sensuous approach to documentary photography is evidenced by the distinct perspective and lighting with which he captures a building's surroundings and nuance, often exploiting weather conditions (fig. 25). In Korab's expressive photograph of the Toronto-Dominion Bank pavilion and towers (part of the Toronto-Dominion Centre in Canada; pl. 23, p. 70[16]); the imposing glass-and-steel grid structure is softened by the gentle fog that envelops the lofty tower, and by the variations of light and dark tones across the entire image. [16]

Korab often photographed tightly cropped sections of buildings, as in *860–880 Lake Shore Drive Apartments* (pl. 24, p. 71), from a complex in Chicago designed by Mies van der Rohe. As elsewhere in Korab's work, the photograph expresses a specific moment and place, setting the building in its historical context. In an asymmetrical, layered composition, the complex's lower stories form a rigid backdrop to the everyday objects and structures: cars, a garage, and a parking meter. In the foreground, the glamorous tail fins of a 1960 Cadillac parked on the street provide a jazzy note of relief to the building's geometry. These contrasting forms, modulated by dark and light tones, are balanced and brought together by a light, wet snow that falls over everything.

The influential work of mid-century photographers like Stoller, Korab, Shulman, and Gottscho transformed our vision and concept of architecture by capturing and celebrating the spirit of modernism. Emphasizing the structures' style and formal grace through their use of lighting, vantage point, camera angle, and framing, these photographers turned documentary images of architecture into art (pls. 25–29, pp. 73-79). Their photographs of houses, corporate offices, factories, institutions, and industrial buildings were featured in numerous popular and specialty magazines, such as *Life*, *Collier's*, *Fortune*, *Town & Country*, *Harper's Bazaar*, *Arts & Architecture*, and *Architectural Forum*, (figs. 22, 23, 24) and thus exposed minimalist design to a vast audience. The photographs not only promoted and popularized the experimental, forward-looking buildings, but elevated their architects, including Charles and Ray Eames, Pierre Koenig, Richard Neutra, Frank Lloyd Wright, Mies van der Rohe, and Eero Saarinen.

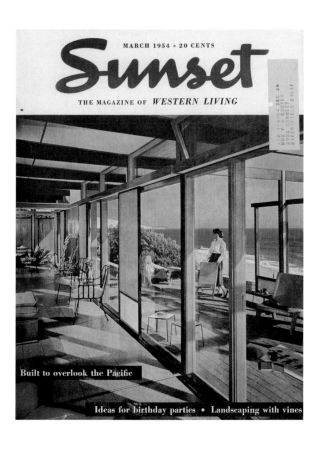

fig. 24 Cover of *Sunset Magazine*, March 1954, vol. 112. Cover photo by Julius Shulman.

continued on page 94

83

fig. 25 Balthazar Korab (Hungarian, 1926–2013), *Reynolds Metals Regional Sales Office (Southfield, MI),* 1959. Courtesy Korab Image, Christian Korab, Minnesota. © 2018 Korab Image.

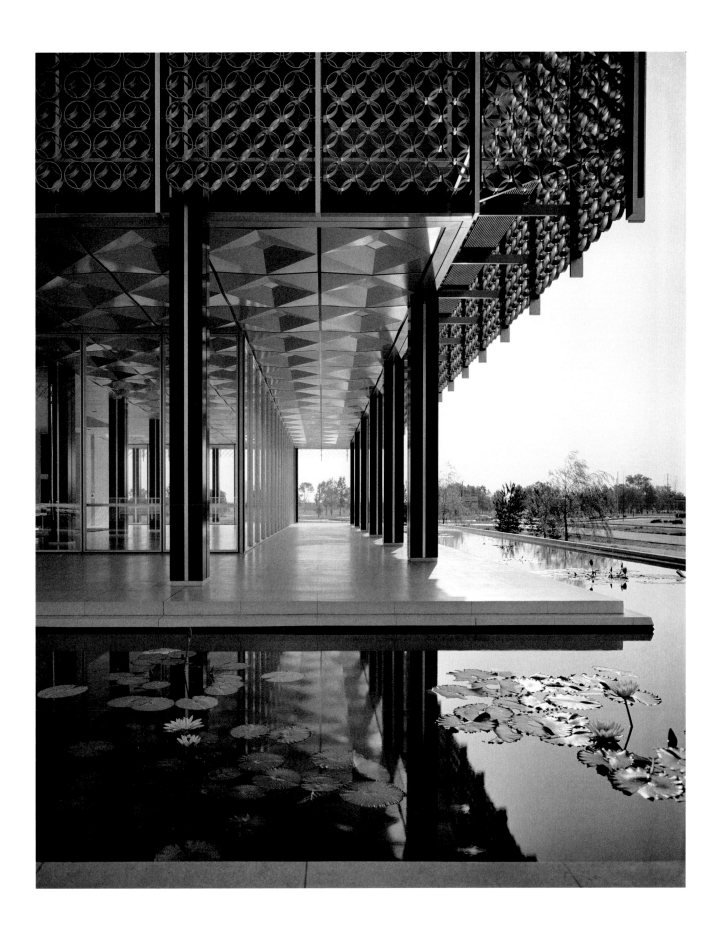

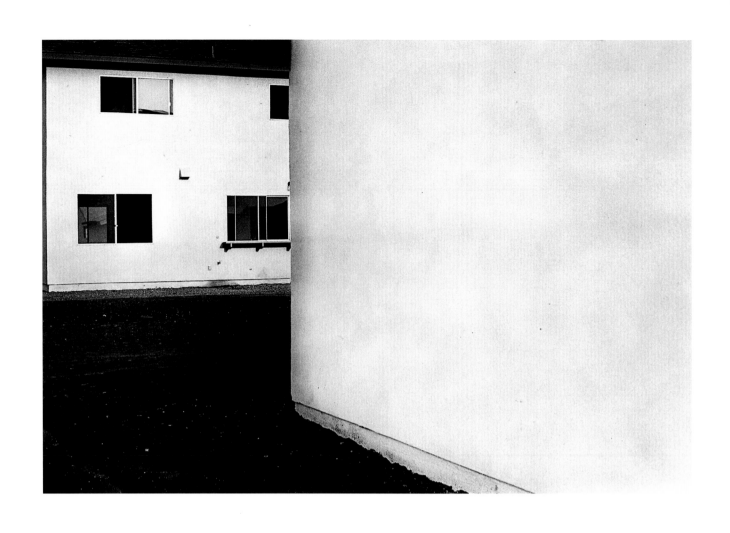

PLATE 30 LEWIS BALTZ (AMERICAN, 1945–2014), *TRACT HOUSE #6*, FROM *THE TRACT HOUSES* PORTFOLIO, 1971

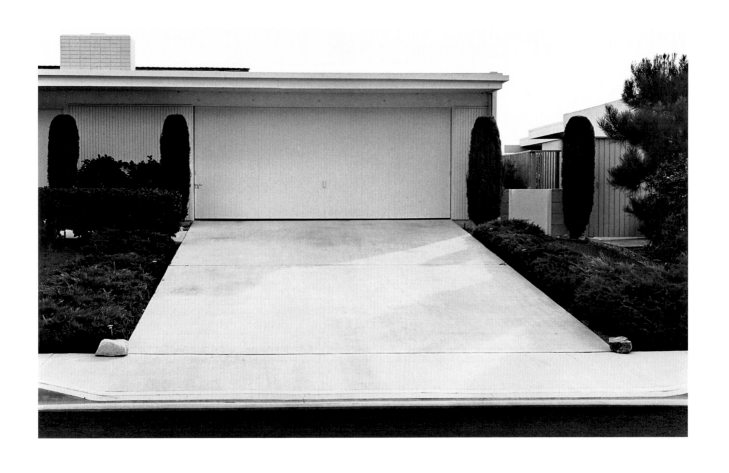

PLATE 31 LEWIS BALTZ (AMERICAN, 1945–2014), *TRACT HOUSE #23*, FROM *THE TRACT HOUSES* PORTFOLIO, 1971

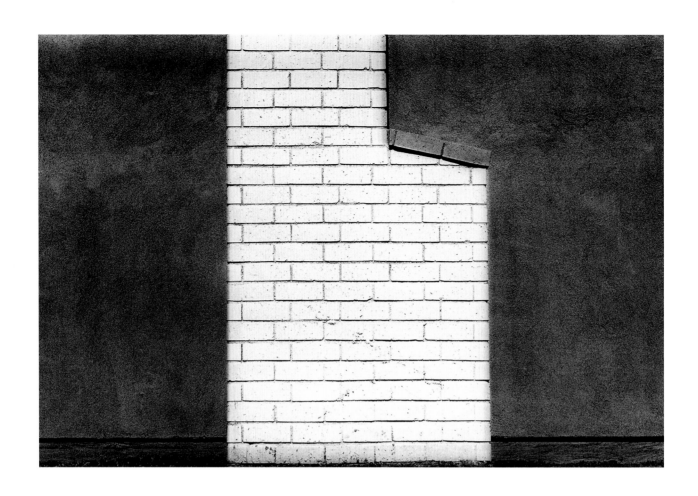

PLATE 32 LEWIS BALTZ (AMERICAN, 1945–2014), *TRACT HOUSE #8*, FROM *THE TRACT HOUSES* PORTFOLIO, 1971

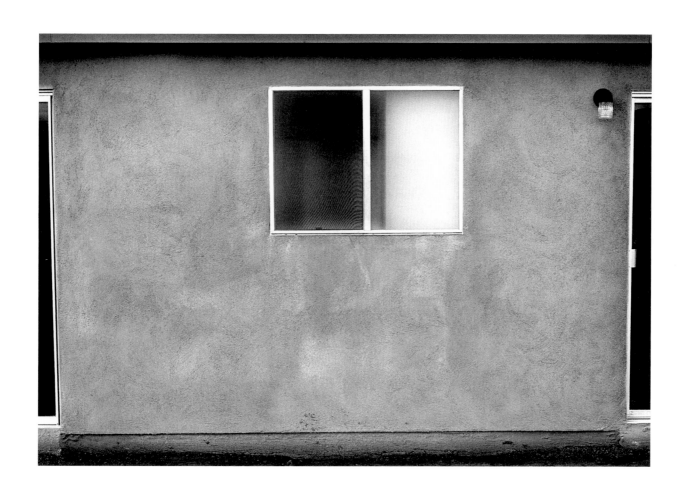

PLATE 33 LEWIS BALTZ (AMERICAN, 1945–2014), *TRACT HOUSE #5*, FROM *THE TRACT HOUSES* PORTFOLIO, 1971

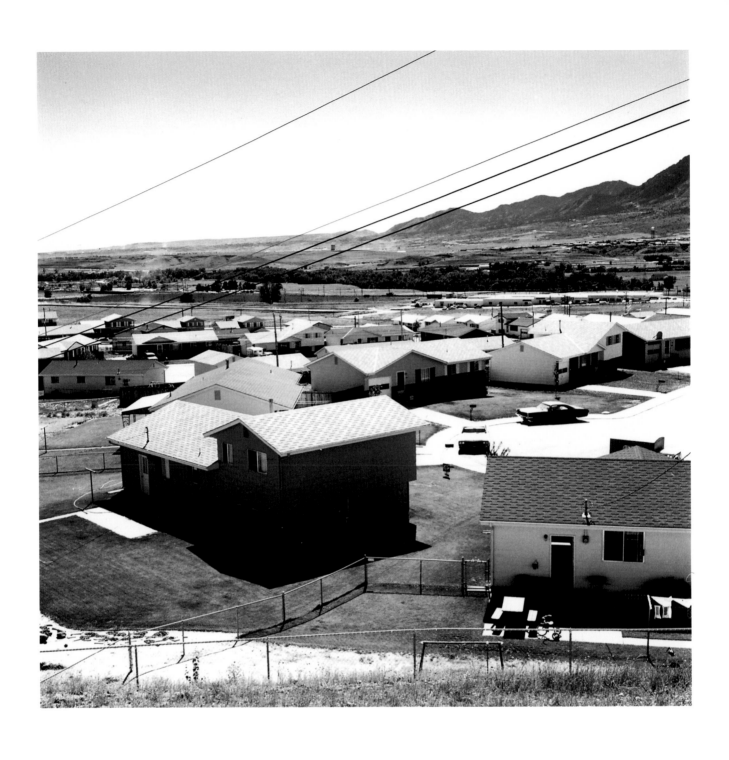

PLATE 34 ROBERT ADAMS (AMERICAN, BORN 1937), *COLORADO SPRINGS, COLORADO,* 1968–1971

90

PLATE 35 ROBERT ADAMS (AMERICAN, BORN 1937), *GOLDEN, COLORADO*, 1968–1971

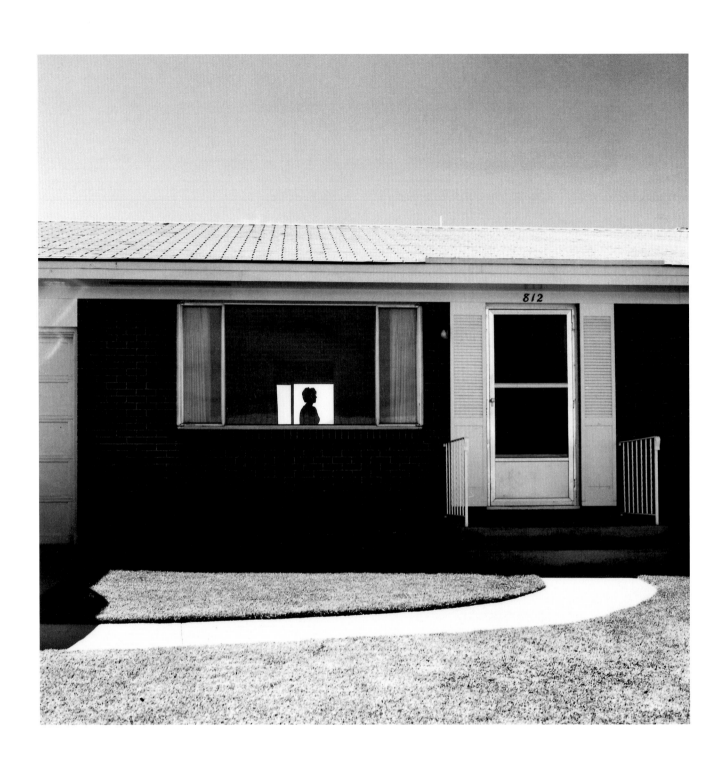

PLATE 36 ROBERT ADAMS (AMERICAN, BORN 1937), *COLORADO SPRINGS, COLORADO,* 1968

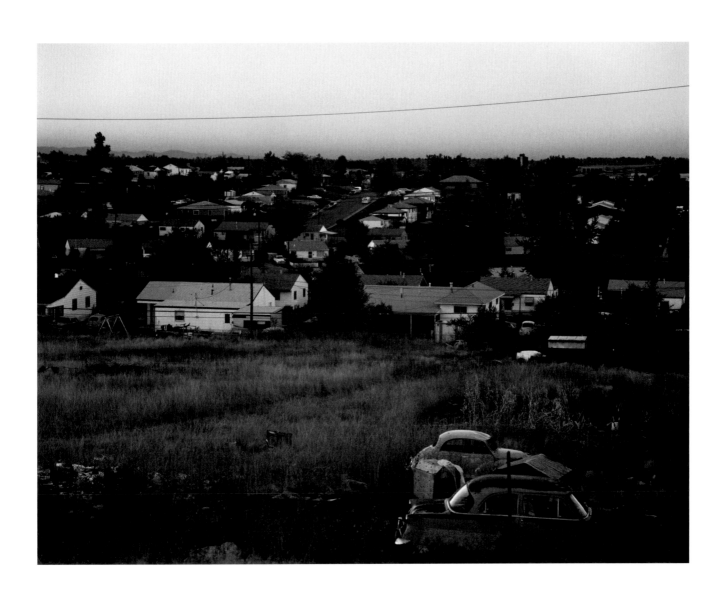

PLATE 37 ROBERT ADAMS (AMERICAN, BORN 1937), *LAKEWOOD, COLORADO*, 1973

Postwar Photography and the American Dream

Post–World War II prosperity and the return of millions of soldiers gave rise to a series of rapid changes that transformed the American landscape. New government-subsidized credit and finance programs, such as the G.I. Bill of 1944 and the Federal-Aid Highway Act of 1956, were established.[17] The movement of the middle class from cities to the suburbs meant a need for more cars, transportation systems, and inexpensive housing. Population growth ushered in the building boom, which inspired one of the earliest progressive utopian experiments, the Case Study Houses program. Launched in 1945 by John Entenza, publisher and editor of *Arts & Architecture* magazine, its goal was to support the American Dream of home ownership by commissioning leading architects to design prototypes of modernist houses that could be inexpensively mass-produced. Twenty-six model homes were built, primarily in California, by eight architects, Saarinen, the Eameses, and Koenig among them. The designs were intended to represent not only a new kind of affordable housing, but also an idealized contemporary way of living.

Julius Shulman (1910–2009), who moved as a boy from the Northeast to Los Angeles, photographed eighteen of the completed Case Study Houses. Through his lighting and camera angles, and by posing elegant models inside and outside the homes, he humanized the minimalist structures of steel, concrete, and glass, making them more desirable to consumers. His images, reproduced in general-interest magazines and trade journals, reflect America's increasing informality, unambiguous gender roles, and suburbanization. But within this everyday environment, Shulman's focus on formal concerns, such as light, shadow, framing, and mood, conjures a magical allure (pls. 25–26, pp. 73–74).

In one of Shulman's breathtaking night photographs of Pierre Koenig's Case Study House #22 (pl. 27, p. 75), two well-dressed women are seated comfortably inside a minimally furnished living room. The house, made of concrete and steel, and with large glass windows, cantilevers over Los Angeles, and part of its roof hangs like a canopy over its frame. The photograph's daring perspective enhances the expansive view and underscores the continuity between indoor and outdoor space, a common feature of the Case Study Houses. Shulman also photographed Case Study House #22 during the day (pl. 28, p. 77).

Shooting across a swimming pool, he reveals how the angles of the flat roof mimic the shape of the pool beneath it and frame the view.

Shulman's spectacular photograph of the Raymond Loewy House (pl. 29, p. 79)—located in Palm Springs, California, and designed by the architect Albert Frey—similarly highlights the low-slung home's connection with its landscape and evokes a sense of generous, unbounded space. The house's beams and lattice roof frame open views of both the surrounding desert and the more distant city; here the pool extends into the living room, a literal flow between inside and outside.

As the rising middle class migrated to the suburbs, the need for affordable housing surpassed the capacity to build homes like the Case Study Houses.[18] Developments of small, unadorned, inexpensive homes sprouted up across the country, with Levittowns (so named in Hempstead, Long Island, New York; Bucks County, Pennsylvania; and Burlington County, New Jersey) being the first mass-produced suburban communities. Levittowns—built by Levitt & Sons—were socially and culturally homogeneous and racially exclusive. Though celebrated at the time as marvels of modern planning and a welcome alternative for young families, such tract housing developments came to be equated with conformity, sterility, and poor construction.

In that environment, a more critical, conceptual, and less idealized documentary view of postwar consumer society appeared in the work of the next generation of photographers, including Lewis Baltz, Robert Adams, and Stephen Shore. They were among the artists featured in a landmark exhibition held in 1975 at the George Eastman House in Rochester, New York. *New Topographics: Photographs of a Man-Altered Landscape* set a trend for photographing banal vernacular buildings and elevating snapshots of everyday architecture to high art, including the work of Bernd and Hilla Becher (fig. 15, p. 33).[19]

This new approach is clearly seen in photographs by Lewis Baltz (1945–2014) of residential developments in the American West (fig. 26), which contrast sharply with Shulman's aspirational and elegant Case Study House photographs. Baltz's small-scale black-and-white images of generic houses under construction in the expanding suburbs east of Los Angeles were photographed with a 35-millimeter camera between 1969 and 1971 (pls. 30–33, pp. 86–89). The buildings appear outmoded even before their completion. Baltz's unromantic, close-up, eye-level

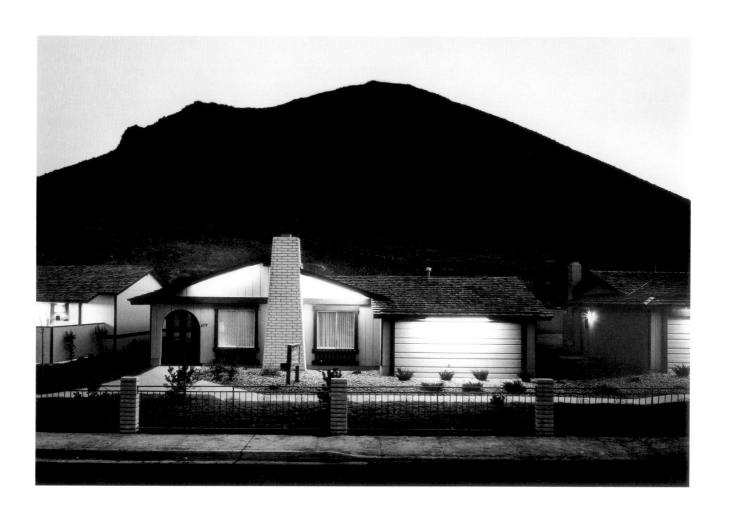

frontal views of their stucco facades convey impenetrable emptiness and ambiguity: it is difficult to judge from the photographs whether the homes are uninhabited because they are in the process of being built or because they have been abandoned. Baltz sought to convey a building's natural life: its evolution between its construction and its ultimate demise. He wanted his early photographs to look like the work of an anthropologist, recording commonplace but marginal, homogenized sites, like the ones in Southern California where he grew up: "I was looking for . . . the things that were the most quotidian, everyday, unremarkable, and trying to represent them in the way that was the most quotidian, everyday and unremarkable."[20] It was, he said, "exactly these kinds of insignificant, entropic phenomena that captured my interest, the things in a stage between their useful lives and their decay."[21]

Although Baltz claimed to have taken these photographs with a "neutral" eye, they are not pure documentary. He creates a deliberate tension between the images' formal beauty—their aesthetically elegant, evenly lit, soft yet grainy surfaces—and the social and economic reality they record. His photographs are a melancholy commentary on postwar alienation and the unfulfilled promises of the American Dream.

Robert Adams (b. 1937), who was born on the East Coast and moved to the suburbs of Denver as a teenager, also spent a number of years photographing houses in the American West. In contrast to Baltz's shallow, almost claustrophobic visual space, Adams sets his subjects in the context of expansive yet barren landscape. His elevated and ground-level perspectives of cookie-cutter homes in Colorado's suburban developments underscore the treeless, sun-bleached topography and the buildings' generic monotony (pls. 34, p. 90; 35, p. 91; 37, p. 93). In one of Adams's close-up images (pl. 36, p. 92), an anonymous woman is seen through a window, silhouetted against the far window of a living room in a modest home. Framing her by including only part of the bleak house, Adams draws attention to her restricted existence. The stark contrast between the dark interior and the harshly sunlight exterior adds to the sense of isolation.

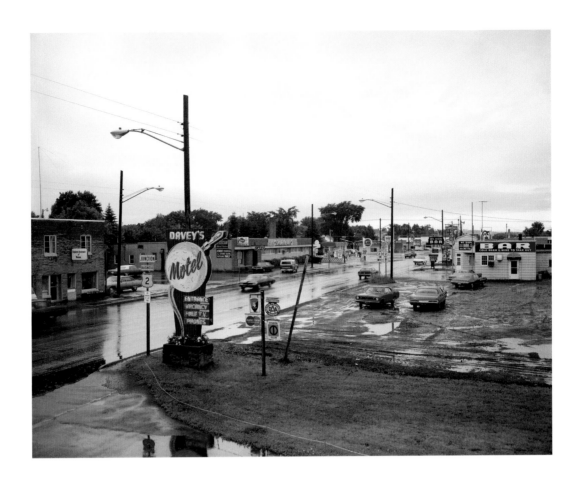

An Explosion of Color

The 1970s brought sharp cultural critiques to fine art photography, as seen in the work of Baltz and Adams, but it also brought the use of color—until then limited largely to billboards, commercial fashion photography, and print advertising. Among the first wave of color photographers were William Eggleston, Joel Sternfeld, and Stephen Shore. Shore (b. 1947), uses color and natural light to intensify his work's realism. His numerous documentary photographs from the 1970s, taken during road trips across America, often evoke film stills; they frequently feature ordinary buildings, such as gas stations, stores, and motels, along with people, cars, traffic lights, and telephone poles with their spiderwebs of wires (pls. 38–39, pp. 100–101; fig. 27).[22] Although Shore carefully composes his images, which require time to set up, they appear spontaneous, as if taken from the window of a passing car. "I wanted to make pictures that felt natural," Shore said, "that felt like seeing, that didn't feel like taking something in the world and making a piece of art out of it."[23] His photographs seem immediate and

fig. 27 Stephen Shore (American, born 1947), *U.S. 2, Ironwood, Michigan, July 9, 1973,* 1973. Chromogenic print, 17 × 21¾ inches. Courtesy 303 Gallery, New York. © 2018 Stephen Shore.

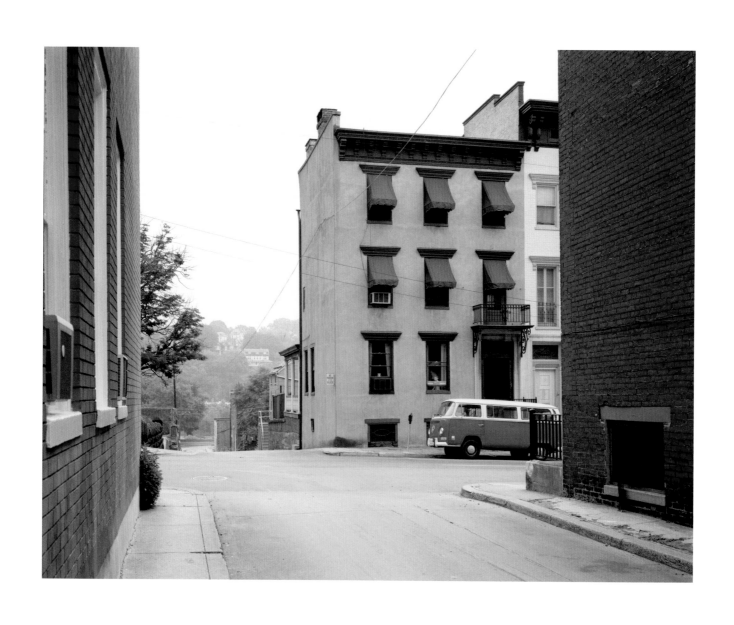

PLATE 38 STEPHEN SHORE (AMERICAN, BORN 1947), *CHURCH STREET AND SECOND STREET, EASTON, PENNSYLVANIA, JUNE 20, 1974*, 1974

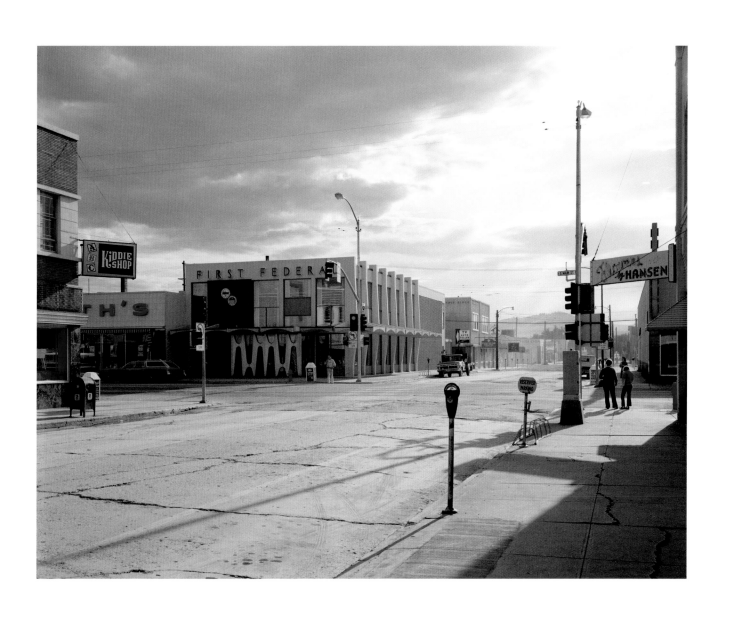

PLATE 39 STEPHEN SHORE (AMERICAN, BORN 1947), *SECOND STREET, EAST AND SOUTH MAIN STREET, KALISPELL, MONTANA, AUG 22, 1974*, 1974

accessible, allowing the viewer to approach the image via the roads that move through it. Like a detective entering a crime scene, we investigate Shore's photographs for the smallest details of the people, places, and things they portray. He places us as witnesses to a scene that feels connected to the past—an inimitable moment of perception.

To capture large, clear, and detailed images, Shore photographed with an 8 × 10 view camera. He "chose a view camera because . . . it's the photographic means of communicating what the world looks like in a state of heightened awareness."[24] This "heightened awareness" encourages the viewer to examine the photographs with curiosity, and also to take notice of the act of viewing. Shore's work reminds us that we see the world not as objective reality, but through images and memories of images.

Through Shore's vividly realistic photographs we recognize, recall, and relive a particular place at a specific moment of the 1970s. By contrast, Luigi Ghirri (1943–1992), his contemporary and fellow pioneer of color art photography, produced dreamlike images that rendered his subjects seemingly timeless. One of Ghirri's areas of focus was the architecture and landscape of his native Emilia-Romagna, Italy, where narrow roads move through industrial towns and fields past colorful facades that often tightly conceal their inaccessible interiors, mutely opaque.[25] His postcard-size photographs—at times, close-up, frontal, cropped views in soft pastels (pls. 41–44, pp. 104–107) convey Ghirri's fascination with material surfaces and the effects of light. His buildings vibrate with the energy of what is hidden beyond their sensuously textured facades. Some of the photographs capture traditional architecture and more contemporary elements, subtly drawing attention to technological and historical change. In one almost hallucinatory scene (pl. 40), modern traffic lights emit a soft orange glow at either side of a timeworn white building, the whole seemingly enveloped in a mist that blurs the difference between solids and air. Such ineffable effects liberate Ghirri's work from a purely documentary function; he has transported an actual site to an imaginary realm that expands in the viewer's imagination. Ghirri referred to his lyrical and playful images as

continued on page 110

PLATE 40 LUIGI GHIRRI (ITALIAN, 1943–1992), *REGGIO EMILIA, F*ROM THE SERIES *KODACHROME,* 1973

PLATE 41 LUIGI GHIRRI (ITALIAN, 1943–1992), *MODENA*, FROM THE SERIES *CATALOGO*, 1971

PLATE 42 LUIGI GHIRRI (ITALIAN, 1943–1992), *MODENA*, FROM THE SERIES *CATALOGO*, 1972

PLATE 43 LUIGI GHIRRI (ITALIAN, 1943–1992), *BONN,* FROM THE SERIES *KODACHROME,* 1973

PLATE 44 LUIGI GHIRRI (ITALIAN, 1943–1992), *RIMINI*, FROM THE SERIES *ITALIA AILATI*, 1977

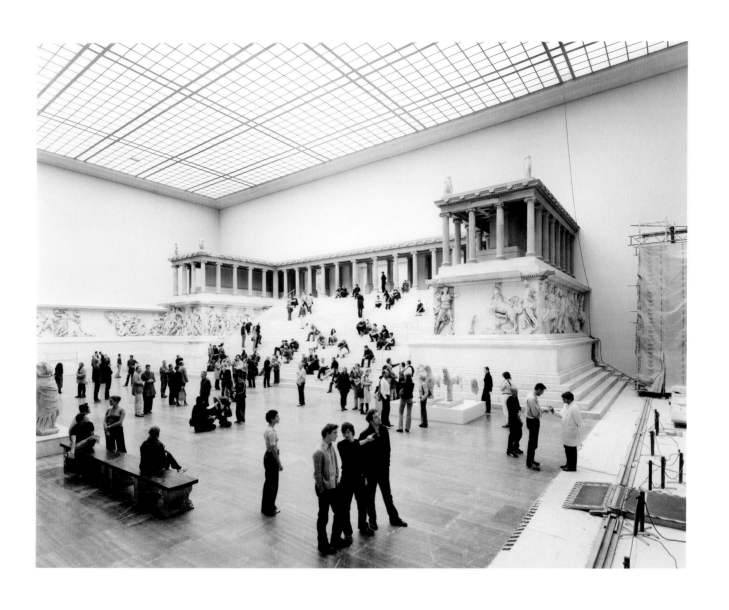

"impossible landscape," articulating the impossibility of strictly accurate or objective photographic representation. Photographs, he wrote, "become our impossible landscape, without scale, without a geographic order to orient us; a tangle of monuments, lights, thoughts, objects, moments, analogies from our landscape of the mind."[26]

The contrast between and combination of the real and the artificial or imaginary has been explored in other ways by James Casebere (b. 1953) and Thomas Demand (b. 1964), whose work hybridizes two distinct processes: handcrafting three-dimensional models and photography. Both artists fabricate and then photograph models of houses and institutional interiors, to produce vaguely artificial-looking photographs bridging fantasy and reality (pls. 47, p. 115; 50, p. 126).

Casebere's photographs are influenced by images from other media: comics, animation, magazines, films, television, and the Internet. Their large scale and heightened color produce an exaggerated sense of place, reminiscent of the hyperrealism of films by David Lynch, such as *Blue Velvet* (1986), and Peter Weir's *The Truman Show* (1998), where nostalgia and dystopia collide to illuminate the psychosocial conditions of postwar suburbia. For Casebere, too, "art is about exaggeration. So I am trying to point to things of significance and to exaggerate certain things for the sake of drawing attention to them."[27]

His symbolic and psychologically charged *Dutchess County* series depicts suburban neighborhoods of upstate New York that Casebere has re-created in sprawling tabletop models (fig. 28).[28] In *Landscape with Houses, Dutchess County, New York, #1* (fig. 29), a view of his model McMansions and manicured lawns, the brightly colored homes

continued on page 116

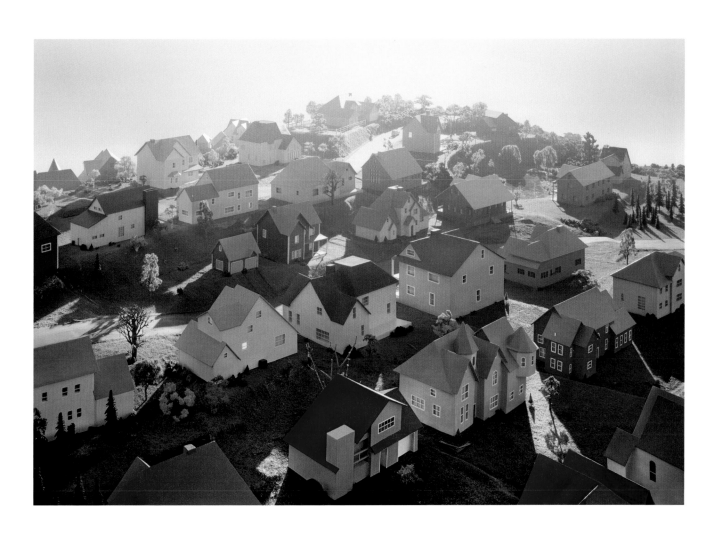

fig. 28 James Casebere (American, born 1953), *Studio View, New York*, 2009. Courtesy the artist and Sean Kelly, New York. © 2018 James Casebere. Photograph by Chris Rodriguez.

fig. 29 James Casebere (American, born 1953), *Landscape with Houses (Dutchess County, NY) #1,* 2009. Chromogenic print mounted to Dibond, 69¾ × 100¼ inches. Courtesy the artist and Sean Kelly, New York. © 2018 James Casebere.

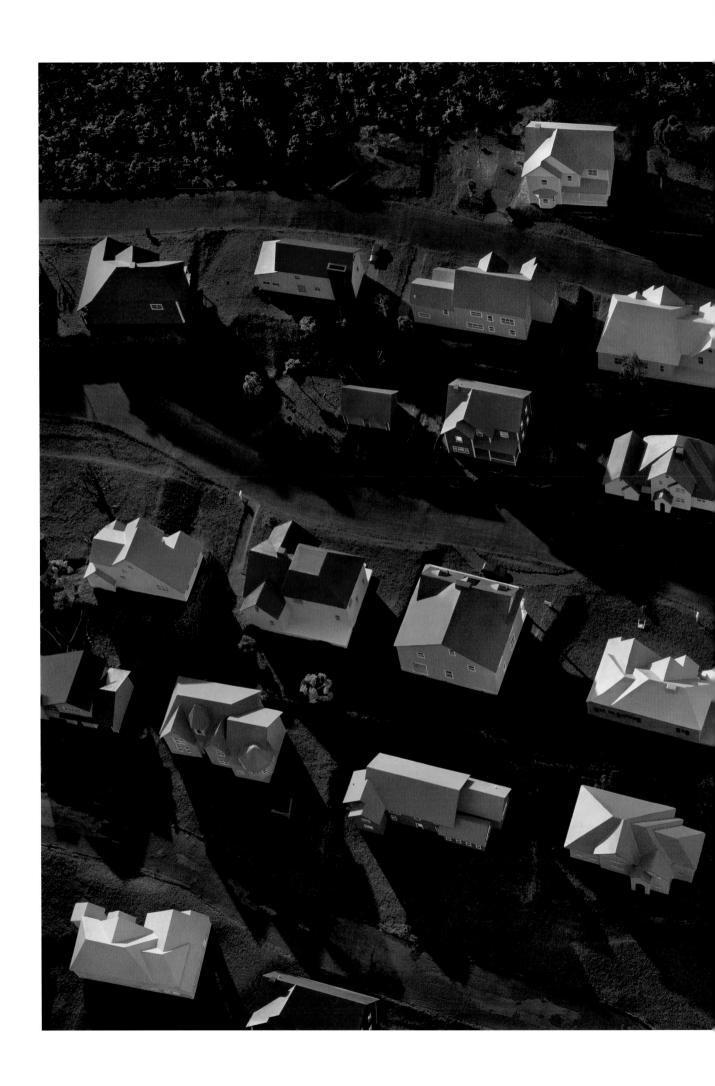

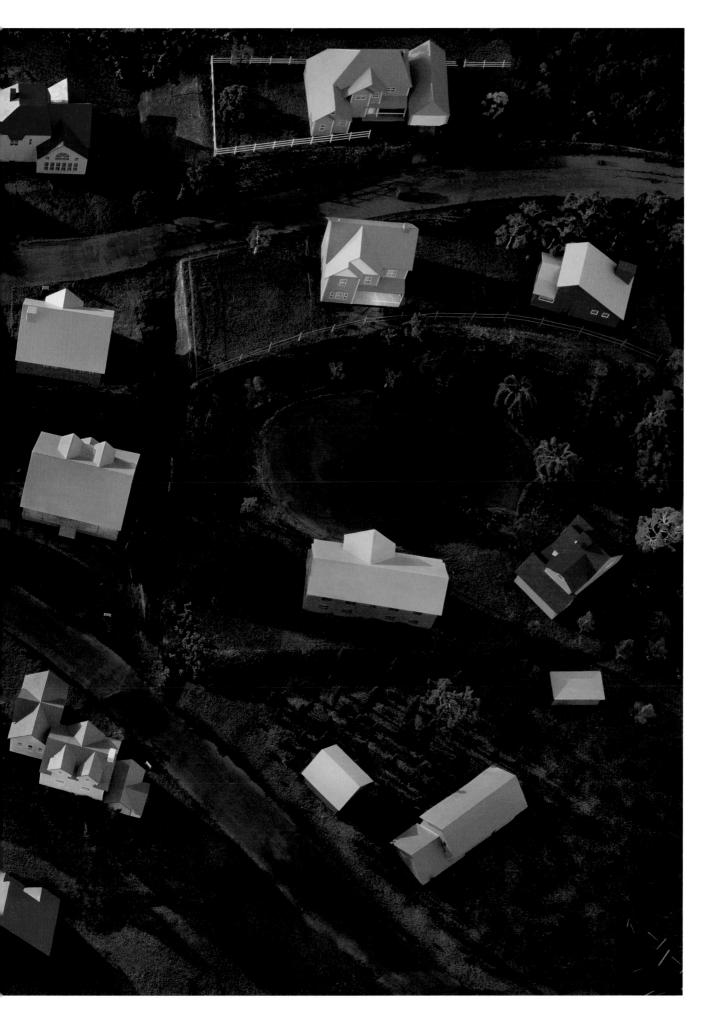

PLATE 46 JAMES CASEBERE (AMERICAN, BORN 1953), *LANDSCAPE WITH HOUSES (DUTCHESS COUNTY, NY) #2*, 2009

PLATE 47 JAMES CASEBERE (AMERICAN, BORN 1953), *YELLOW OVERHANG WITH PATIO*, 2016

are unfinished, devoid of people, and bathed in a soft, diffuse light. The elevated perspective suggests a land survey or surveillance war photography. Both that critical distance and the artifice are further emphasized by the size of the photograph, which measures about six feet, two inches by eight feet, nine inches.

The series addresses the United States' subprime mortgage crisis of 2007–2009, but it also resonates with Casebere's memories of growing up in the Detroit suburbs during the 1950s and 1960s (pl. 46, pp. 112–113). The ghost towns in his photographs allude to economic distress, a crisis of domesticity, and a sense of loss tied to the faltering American Dream. At the same time, their calm and comforting light, sunshine, and bright colors suggest nostalgia for the postwar middle-class faith in "Home Sweet Home" consumerism, and the certainty that life will continue to improve, generation after generation. Perhaps their fairy-tale sweetness also implies a hope that those verities may someday be restored.

The model is as important to Thomas Demand as it is to Casebere; it is part of the very meaning of the photograph. Demand, who trained

fig. 30 Thomas Struth (German, born 1954), *Pond, Anaheim*, 2013.
Inkjet print, 57 × 80 inches. Courtesy the artist and Marian Goodman
Gallery, New York. © 2018 Thomas Struth.

as a sculptor and also makes films, uses colored paper and cardboard to construct life-size architectural models, drawing his subjects from memory and from images in periodicals, postcards, and paintings. He incorporates intentional imperfections—uniform textures, lack of surface detail, and small tears or marks—to underscore the models' artificiality. The photographs' hyperreal clarity, unnatural light, and lack of depth of field further accentuate the artifice: the blankly empty images are reproductions of reproductions in another medium of structures that did not and do not exist. They reflect on the simulacrum of contemporary life in a world driven by technology and media. "I like to imagine the sum of all the media representations of the event as a kind of landscape," he says, "and the media industry as the tour bus company that takes us through these colorful surrounds."[29]

Demand's photographs often allude to political and social events. *Flur/Corridor* (p. 127) makes reference to the hallway leading to serial killer Jeffrey Dahmer's apartment. Similar to a hotel room cleaned after its inhabitants have departed, Demand's deserted interior removes all trace of human presence and narrative.

A cool, evenly lit surface replaces the luminous, romantic light of Casebere's photographs. Yet Demand's seemingly dispassionate images, produced with eight-by-ten-inch large-format and with digital cameras, elicit loneliness, longing, and even despair. Demand sees himself as a conceptual artist and refers to his photographs as images with no history, "a ghost of my vision."[30] They are ghosts, too, of Demand's models, which he destroys immediately after photographing them. Implicitly comparing his artificial constructions to a flower at the pinnacle of its bloom, he said: "They have one peak of perfectness, of immaculate beauty, sometimes just for a day or two. If you don't catch the shot on that day, it's gone."[31]

Thomas Struth (b. 1954) also has trained his lens on artificial environments—not architectural models but actual buildings, from Disneyland (fig. 30) to Las Vegas. Struth is "interested in history and architecture; how a community represents itself in the built environment and what that can tell us about that community."[32] His images express their subjects' palpable atmosphere and nuanced qualities through unusual perspectives, proximity, and dynamic contrasts. *Las Vegas 1, Nevada* (pl. 53, p. 129), features the Treasure Island Hotel &

Casino, with a simulated Caribbean port town set against a high-rise hotel. The strange juxtaposition of the somewhat generic hotel and the kitschy Treasure Island simulacrum, complete with pirate ships and turquoise-blue water in the middle of the desert, communicates the ostentatious fantasy that is Las Vegas.

Even ordinary places appear spectacular in Struth's images, which are extremely large in scale (often exceeding six by eight feet) yet intimate in their warmth and detail, a combination that invites close examination. *Dallas Parking Lot, Dallas* (pl. 52, p. 128), photographed during a building boom, illustrates the beauty Struth sees in the everyday material world while it tells a larger story about the city. Viewed across a rooftop parking lot dappled with large, reflective puddles after rain, Dallas appears fresh and clean. Early-morning inactivity is marked by the absence of people and the sporadic arrangement of a few cars in the lot. The tranquil cityscape shows the historical development downtown; the older, lower, redbrick and ochre buildings are located in the middle ground; behind them, newer, glassy skyscrapers rise at various angles against a hazy sky. Here Struth achieves his goal: to find an "emblematic photograph of a city: a work which has more general qualities, and which can offer a more epic narrative within a single picture."[33] Like Stephen Shore's work, Struth's detailed color photographs of buildings and cities convey the immediacy and singularity of the commonplace and emphasize the process of looking, enabling us to see everyday buildings and objects as if for the first time.[34]

Struth's photographs of public museums expand upon this theme, examining the ritualistic activity of looking at art. His *Museum* series also raises ontological questions about our individual and cultural understanding of the past and its relation to the present. In *Pergamon Museum 1, Berlin* (pl. 45, p. 109), part of Struth's group of six images of the ancient altar, visitors are scattered around the altar, reconstructed inside Berlin's Pergamon Museum.[35] Some sit on the sweeping steps, surrounded by the magnificent marble reliefs of the Gigantomachy and Telephos friezes, while others stroll through the large space. Natural light, which filters through the ceiling's translucent gridded glass, evenly disperses over altar and visitors alike. Our focus, from slightly above the expansive scene, moves back and forth along diagonals from the foreground into the deep background. The photograph

fig. 31 Candida Höfer (German, born 1944), *Teatro di Villa Mazzacorati di Bologna II 2006,* 2006. Chromogenic print, 78³⁄₄ × 100¹³⁄₁₆ inches. Courtesy Sean Kelly, New York and Sonnabend Gallery, New York. © 2018 Candida Höfer, Köln/ Artists Rights Society (ARS), New York / VG Bild-Kunst, Bonn.

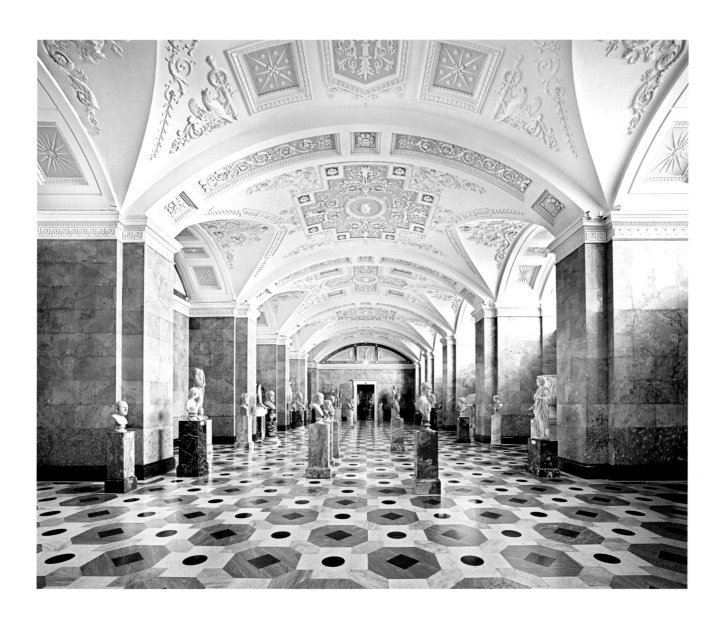

fig. 32 Candida Höfer (German, born 1944), *Hermitage St. Petersburg VII 2014*, 2014. Chromogenic print, 70⁷⁄₈ × 83¹⁄₁₆ inches. Courtesy Sean Kelly, New York and Sonnabend Gallery, New York. © 2018 Candida Höfer, Köln/ Artists Rights Society (ARS), New York / VG Bild-Kunst, Bonn.

looks unposed and spontaneous, but Struth carefully staged all of the photographs in the Pergamon series, unlike his other museum photographs.

Although both museumgoers and viewers of the photograph can project their thoughts and fantasies onto the realistic, emotionally powerful Hellenistic artifacts on display, no one has any hope of an "originary" experience when viewing fragments of antiquity far removed from their original location. All viewers are displaced from the ruins' place of origin, but the viewer of the photograph is doubly displaced: from the altar's original site and from the museum itself. Even at the original site of a ruin, it is impossible to experience the "what was." Struth's photographs emphasize the jarring gap between the past and the present.

Like Struth, Candida Höfer (b. 1944) is interested in themes of history, place, and time. She grew up in the immediate aftermath of World War II in Cologne, where many buildings were completely destroyed or left in ruins. Perhaps in response to the trauma of war and feelings of loss, she photographs solid and stable interiors, symbolically preserving buildings. Her frontal, panoramic views of the unoccupied interiors of public institutions such as libraries, churches, opera houses, and museums are photographed from an elevated vantage point (pl. 48, p. 119; figs. 31–32, pp. 120–121). With their evanescent illumination and soft colors, these pristine, symmetrical, detailed images often border on abstraction, making public buildings look like flawless jewels. Calm and meditative, realistic yet dreamlike, Höfer's unpeopled interiors invite us to think about the physical and social spaces we occupy and to "enter" the large-format photographs (many larger than six by seven feet) through our imaginations. The experience is similar to the thrill of exploring a building that is closed to the public. At the same time, her images precipitate a sense of anticipation—waiting, perhaps, for people to arrive. As Höfer stated, "I wanted to capture

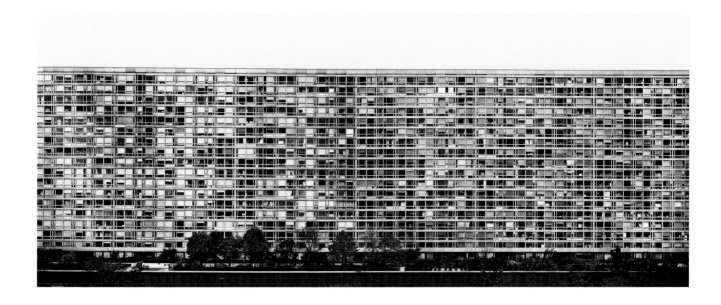

how people behave in public buildings. . . . After some time, it became apparent to me that what people do in these spaces—and what these spaces do to them—is clearer when no one is present, just as an absent guest is often the subject of a conversation."[36]

Höfer studied at the Kunstakademie in Düsseldorf along with Struth, Thomas Ruff, Andreas Gursky, and others; the group is now known as the Düsseldorf School. Gursky (b. 1955) makes digitally manipulated large-scale color photographs of apartment buildings, hotels, banks, and stock exchanges around the world (pl. 49, p. 125). Breathtaking and panoramic, they suspend the viewer before the

buildings, which appear to fluctuate between two- and three-dimensionality. *Paris, Montparnasse* (fig. 33) is Gursky's rendering of the Mouchotte Building, an example of the massive modernist housing projects France undertook in the aftermath of the destruction of World War II.[37] Gursky digitally combined two photographs of the building into one seamless, monumental image. Depth of field is collapsed, and the facade, close and parallel to the picture plane, becomes a colorful, almost abstract grid of apartments, resembling a mosaic or tapestry. Both the horizontal building and the band of sky above it continue to the edge of the frame and overshadow a line of trees in the shallow foreground.

Gursky carefully spliced together multiple negatives to create *Shanghai* (fig. 34), a vertical image of the interior floors of that city's Grand Hyatt Hotel. As our eyes scan the stacked curves that extend to the edge of the photograph, it is difficult at first to understand what we are looking at. The opulent hotel is rendered as an abstract golden surface. We hardly notice the few minuscule people dotting various floors, dwarfed by the architecture. This disorienting image conveys the alienating effects of global capitalism on everyday lives. Notwithstanding that sharp message, the sumptuous beauty seduces. This dichotomy invites a subjective, aesthetic, conceptual, and

continued on page 132

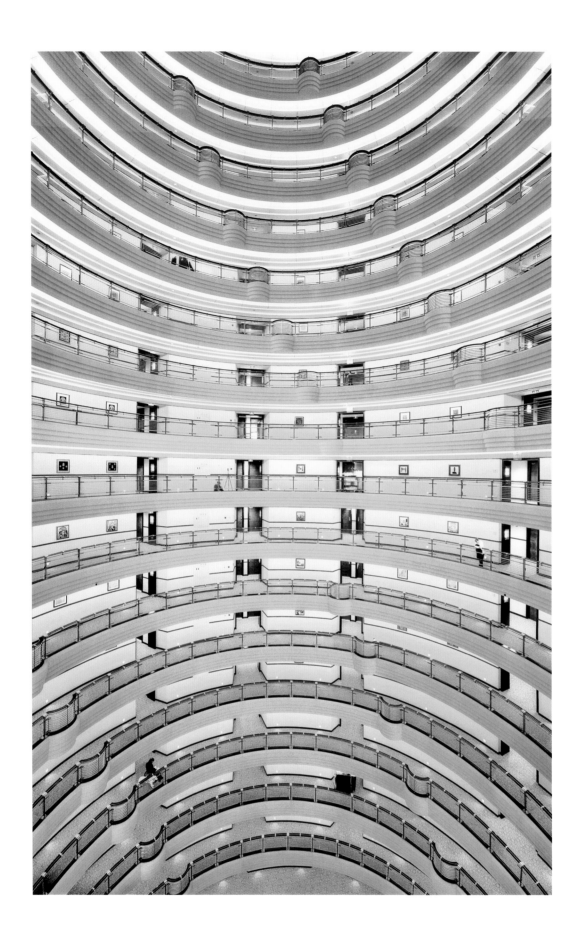

fig. 34 Andreas Gursky (German, born 1955), *Shanghai*, 2000.
Chromogenic print face-mounted to acrylic, 118¾ × 81½ inches.
The Doris and Donald Fisher Collection at the San Francisco Museum
of Modern Art. © 2018 Andreas Gursky/Artists Rights Society (ARS),
New York/ VG Bild-Kunst, Bonn/ Courtesy Sprüth Magers Berlin
London. Photograph by Ian Reeves.

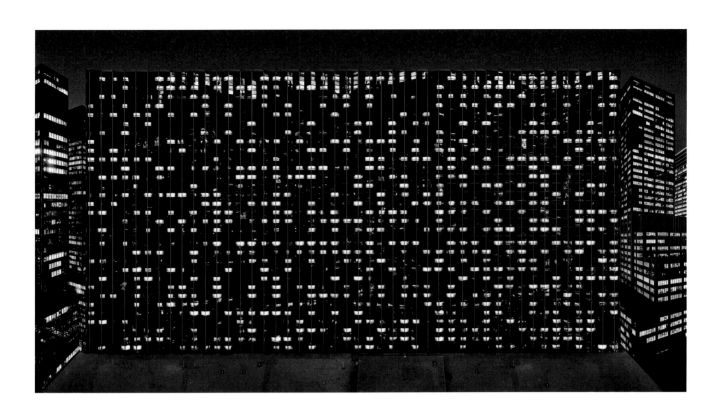

PLATE 50 THOMAS DEMAND (GERMAN, BORN 1964), *MODELL*, 2000

PLATE 51 THOMAS DEMAND (GERMAN, BORN 1964), *FLUR (CORRIDOR)*, 1995

PLATE 52 THOMAS STRUTH (GERMAN, BORN 1954), *DALLAS PARKING LOT, DALLAS*, 2001

PLATE 53 THOMAS STRUTH (GERMAN, BORN 1954), *LAS VEGAS 1, NEVADA*, 1999

PLATE 54 HÉLÈNE BINET (SWISS-FRENCH, BORN 1959), *FELDKAPELLE FÜR DEN HEILIGEN BRUDER KLAUS 06 (ARCHITECTURE BY PETER ZUMTHOR)*, 2007

PLATE 55 HÉLÈNE BINET (SWISS-FRENCH, BORN 1959), *CHRIST CHURCH IN SPITALFIELDS 02 (ARCHITECTURE BY NICHOLAS HAWKSMOOR)*, 2013

philosophical engagement with the work, and alters our understanding of the architecture itself.[38]

As Gursky does, the Swiss-French photographer Hélène Binet (b. 1959) captures buildings' visual beauty with an abstraction that heightens awareness of the effects of light, the materiality of forms and textures, and the very process of looking, as we try to determine what we are looking at (pls. 54–55, pp. 130–131). Unlike Gursky's vision of architecture as spectacle, Binet's photographs, rich in tone and texture, subtly reveal a building's atmosphere and mood: "I prefer to have silent, abstract images, that by looking at them you have an interaction. You create your own space, which maybe is not the exact space, but it is more real than a wide-angle descriptive photograph. I often refer to the space you create when you read a book or have a dream."[39]

Binet usually works with an Arca-Swiss four-by-five-inch-format camera, using film instead of digital photography to enhance the quality of light and shadow on forms. Of her analogue technique she has said: "I like to produce something I can touch with my hands. . . .

fig. 35 Iwan Baan (Dutch, born 1975), *Torre David, Caracas, Venezuela,*
2011. Courtesy Moskowitz Bayse Gallery, New York. © 2018 Iwan Baan.

Using the hand is a way of thinking. I like limitation as a creative process, rather than possibility. . . . With film, you have to make a decision on the spot."[40]

In contrast to Binet's lush abstractions, Iwan Baan's photographs often take an almost journalistic or sociological approach: they portray architecture in its larger context, presenting a dynamic picture of a building's function and meaning. His 2007 series on the Torre David (Tower of David, so nicknamed after its developer/financier David Brillembourg), an unfinished forty-five-story skyscraper in Caracas, reveals the physical struggle, resilience, and perseverance necessary for self-sustaining collective housing.

Construction of the complex began in 1990 but was interrupted in 1994 by the collapse of the Venezuelan economy. Systemic problems continued to plague the country, and by 2004, government corruption and inefficiency gave rise to widespread housing shortages in the capital and elsewhere. These conditions led to the occupation and repurposing of the Torre David: towers that had been intended to house financial institutions and luxury apartments were settled by squatters, who found it more desirable to live in a half-finished skyscraper than in the overcrowded and dangerous favelas. Families occupied the first twenty-eight floors of the tower, although only the ten lowest floors could be accessed by cars; beyond that, occupants had to walk up.

Baan presents a somewhat abstract, telescopic view of the unfinished structure from inside an atrium (pl. 57, p. 135). The soaring perspective extends from the ground level upward through an oculus to a hazy, blue sky. This disorienting viewpoint expresses both the hope and the precariousness of the residents' lives. Potted plants on a window ledge remind us of the domesticity within. In an image of the facade (pl. 56, p. 134), the partially constructed and variously decorated windows form a patchwork grid. In a more intimate close-up view through a rough and unevenly cut window (its maroon painted frame set against a chipped stucco wall), Baan humanizes the unforgiving architecture by showing its inhabitants: a smiling young mother holding her infant inside a vibrantly colored bodega (fig. 35).[41]

continued on page 137

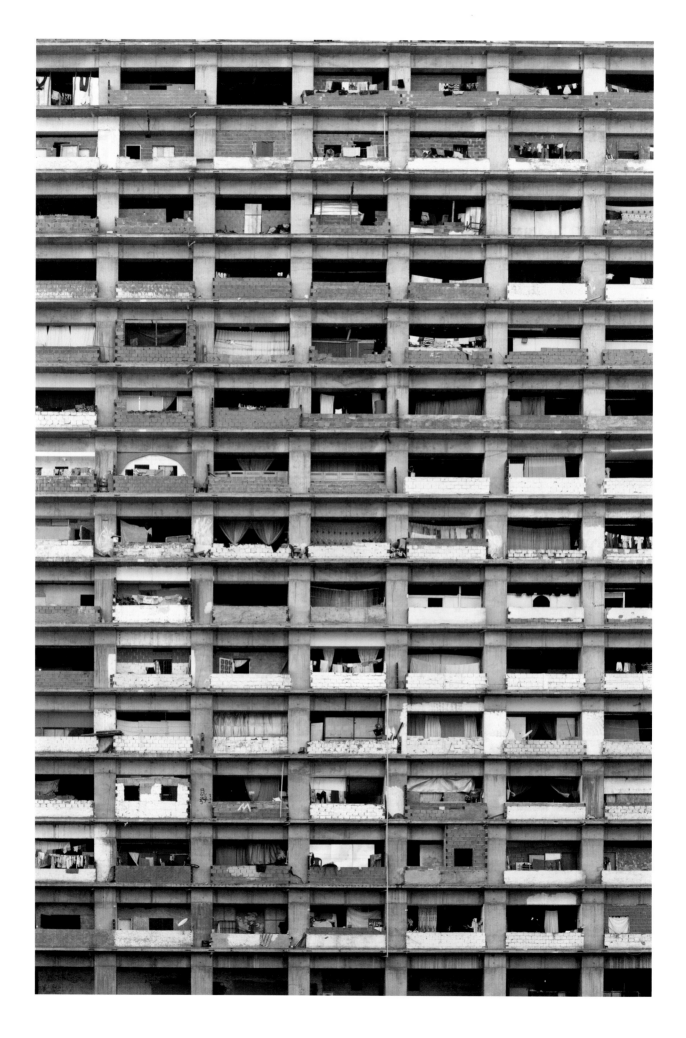

PLATE 56 IWAN BAAN (DUTCH, BORN 1975), *TORRE DAVID #1*, 2011

PLATE 57 IWAN BAAN (DUTCH, BORN 1975), *TORRE DAVID #2*, 2011

fig. 36 Hiroshi Sugimoto (Japanese, born 1948), *Villa Savoye–Le Corbusier*, 1998. Gelatin silver print. Courtesy Fraenkel Gallery, San Francisco. © 2018 Hiroshi Sugimoto.

Representing a Time That No Longer Exists

Although both photographs and architecture seem to be unchanging—the former capturing a fixed moment in time, the latter solidly constructed of impermeable materials—photographs, architecture, and our understanding of them has always been mutable. As buildings and photographs of them transform over time, each one mediates our perception of the other in an ongoing process of changing meanings and associations. The Villa Savoye, Poissy, France, a reinforced concrete building designed by Swiss architects Le Corbusier and Pierre Jeanneret, was built between 1928 and 1931. Sugimoto's blurry, dreamlike image of the building, photographed a year after its 1997 renovation (fig. 36), ironically refers to its condition before its renovation. It appears as a photographic trace of both its presence and its eventual dissolution; it will become what it once was—a ruin.

When the Case Study Houses were newly built, they were seen as cutting-edge designs that exemplified glamorous living. When Julius Shulman photographed them in 1960, he "preserved" them in that condition. Decades later, both his photographs and the houses themselves are seen as nostalgic artifacts of a bygone era. (Today, many of the Case Study Houses have undergone major restorations; some have been destroyed.) And while Iwan Baan's 2007 images of the Torre David seem to capture an indisputable truth about the struggle for survival at a difficult moment in Venezuela's history, we cannot imagine how they will be perceived years from now; we know only that they will be perceived differently.

Siegfried Kracauer (1889–1966), a German cultural critic associated with the Frankfurt School of critical theory, wrote in his philosophical essay "Die Photographie" (1927) about the impossibility of responding to images from the past as viewers did at the time of their creation. He describes how contemporary viewers perceive past epochs through cultural "artifacts," such as clothing designs, films, architecture, and photographs; items like these are seen only as dated representations of the period, stripped of their originality or newness: "Past styles and tastes are now costumes, external autonomous decorations. . . . Photography is a representation of a time that no longer exists. Time makes images of itself out of those details, what now appear as costumes or period pieces. Photography is bound to time in precisely the same way as *fashion*."[42]

Notwithstanding the unbridgeable gap between past and present, a theme Struth explores in his *Museum Photographs* series, architectural photographs resonate across time. They inform our memories and understanding of a society's desires and an era's social, economic, and aesthetic concerns. In that way, Samuel Gottscho's inspiring visions of a towering and vigorous New York bring alive an aspect of the 1930s even as they remind us of the great distance between the city portrayed and the city of today.

And yet we must recall that photographs, whether "straight" documentary or digitally manipulated works, represent a subjective interpretation, expressed through choices that include framing, lighting, and camera angle. "Photography pretends to show reality," Thomas Ruff observed,[43] and indeed, Gottscho convincingly captured a glorious aspect of New York while temporarily ignoring the Depression's grim challenges. So it is that, image by image, as if brick by brick, we assemble our own multilayered sense of the built environment through many photographers' lenses and unique perspectives. We could not envision the world, remember it, and know it as we do without their pictures of places.

1 Kenneth Clark, "Heroic Materialism," episode 13 of *Civilisation*, BBC, https://www.youtube.com/watch?v=nK6UpqNctkQ.

2 Donald Albrecht, *The Mythic City: Photographs of New York by Samuel H. Gottscho, 1925–1940* (New York: Museum of the City of New York and Princeton Architectural Press, 2011), p. 30.

3 The print issue was dated November 12, 2012; the title article and the photograph can be found online at http://nymag.com/news/features/hurricane-sandy-2012-11/.

4 Amy Frearson, "New York After the Storm," *Dezeen*, November 5, 2012, https://www.dezeen.com/2012/11/05/new-york-after-the-storm-by-iwan-baan/.

5 "I Make My Picture on the Surface: Visiting Thomas Ruff in Düsseldorf" (based on interview with Philip Ursprung), in *Herzog & de Meuron: Natural History,* ed. Philip Ursprung (Basel: Lars Müller; and Montreal: Canadian Centre for Architecture, 2002), p. 163.

6 Statement on webpage for *M.A.R.S.* exhibition, Gagosian, London, March 8–April 21, 2012, https://www.gagosian.com/exhibitions/thomas-ruff--march-08-2012-2.

7 Herzog & de Meuron submitted Ruff's photograph as its entry for the Venice Biennale Architecture Pavilion in 1991.

8 It is important to Herzog & de Meuron that the firm's architecture relates to the function of the building. In my correspondence with Veronique Ansorge, Director of the David Zwirner Gallery, August 10th, 2017, she explained, "when [Ruff] printed the original photograph, the inside of the building with the fluorescent light was green against the daylight outside. So he used the color adjuster until the inside had a neutral light, and in doing so, the outside became violet".

9 According to Ansorge, " "*w.h.s.*" is the short title for "Weißenhofsiedlung Stuttgart" and "*d.p.b.*" is the short title for "Deutscher Pavillon Barcelona", the names of Ludwig Mies van der Rohe-designed buildings that the images depict. [Ruff] did not shoot "w.h.s" himself -- instead, MoMA provided him with black and white archival photographs, which he then colored and altered."

10 Hiroshi Sugimoto biography, Artsy, https://www.artsy.net/artist/hiroshi-sugimoto.

11 Jun'ichiro Tanizaki, *In Praise of Shadows*, trans. Thomas J. Harper and Edward G. Seidensticker (New Haven: Leete's Island Books, 1977), p. 18. Sugimoto's exhibition, *In Praise of Shadows* was held in 2015 at the Yoshii Gallery, New York City; see http://www.artnet.com/galleries/yoshii-gallery/hiroshi-sugimoto-in-praise-of-shadows/; http://www.sugimotohiroshi.com/praise.html.

12 https://www.sugimotohiroshi.com/new-page-5/?rq=architectur. According to author's correspondence with the Marian Goodman Gallery, July 5, 2017, "The Architecture Series began as a result of a commission in 1997 from Richard Koshalek, then Director of the Museum of Contemporary Art (MoCA) L.A. and Elizabeth Smith then Curator at MoCA to Sugimoto to be part of the exhibition *At the End of the Century: One Hundred Years of Architecture*. The resulting works from that invitation in 1997 were shown in the group exhibition's first venue at MCA December 1999 – March 2000, and then the second venue MOCA, April 2000-September 2000."

13 Webpage for *Hiroshi Sugimoto: Architecture* exhibition, Fraenkel Gallery, San Francisco, December 4, 2003–January 31, 2004, https://fraenkelgallery.com/exhibitions/architecture-2.

14 The Citicorp Building, or Citicorp Center, was completed in 1977; its name was changed a couple of times: first to Citigroup Center and then to its address, 601 Lexington Avenue. Stoller also produced color photographs of the Seagram Building in 1958 and 1991, illuminating the unique facade of bronze-toned nonstructural I-beams and gray-topaz windows that contrasted with the buildings around it. For a discussion, see John Morris Dixon, "Architectural Photography," in *Ezra Stoller, Photographer,* ed. Nina Rappaport (New Haven: Yale University Press, 2012), pp. 25–26.

15 Korab emigrated from Hungary to France in 1949, where he studied architecture. Soon after moving to the U.S. from Paris, in 1955, he worked closely with Eero Saarinen on various architectural projects, and often photographing Saarinen's models of the TWA building.

16 The building was designed by Mies van der Rohe and completed in 1967.

17 The G.I. Bill was officially the Servicemen's Readjustment Act.

18 Though intended to be affordable and mass-producible, the Case Study Houses proved too site-specific and complex to build cost-effectively on a large scale and too advanced in design for the mass market.

19 William Jenkins. *New Topographics: Photographs of a Man-Altered Landscape,* exh. cat. (Rochester, NY: International Museum of Photography at the George Eastman House, 1975). Bernd and Hilla Becher, Frank Gohlke, Nicholas Nixon, Joe Deal, John Schott, and Henry Wessel, Jr., were also in the exhibition. The Bechers documentary and conceptual approach to photography produced a number of groundbreaking and aesthetically innovative series of images, typologies of industrial and domestic buildings and structures often arranged in grids, which they referred to as "anonymous sculptures." Their work had a powerful impact on future generations of international artists.

20 Sean O'Hagan, "Lewis Baltz Obituary," December 4, 2014, *The Guardian,* https://www.theguardian.com/artanddesign/2014/dec/04/lewis-baltz.

21 Jean-Pierre Greff and Elisabeth Milon, "Interview with Lewis Baltz—Photography Is a Political Technology of the Gaze" (1993), American Suburb X, March 11, 2011, http://www.americansuburbx.com/2011/03/interview-interview-with-lewis-baltz.html.

22 These images were included in Shore's book *Uncommon Places,* first published in 1982 (rev. ed., New York: Aperture, 2015). In 1973, Shore switched to a larger format, because he wanted larger negatives to produce larger prints. During this period, he shifted his focus from interior shots to exterior views of commonplace architecture, parking lots, and street intersections.

23 Ben Crair, "'Then I Found Myself Seeing Pictures All the Time!'" *New Republic,* October 22, 2013, https://newrepublic.com/article/115243/stephen-shore-photography-american-surfaces-uncommon-places.

24 Statement on webpage for *Uncommon Places* exhibition, Multimedia Art Museum, Moscow, March 30–May 9, 2012, http://www.mamm-mdf.ru/en/exhibitions/uncommon-places/.

25 Ghirri's Kodachrome series of architecture, towns, landscapes, and billboards was (like most of his other series) conceived as a small book, which was first published in Italy in 1978. In its pages, he deliberately juxtaposed the images to create unexpected parallels and distinctions so that each image is seen afresh. The book, *Kodachrome,* was reissued in 2012 (London: Mack).

26 Statement on *The Impossible Landscape* exhibition webpage, Matthew Marks Gallery, New York, February 26–April 30, 2016, http://www.matthewmarks.com/new-york/exhibitions/2016-02-26_luigi-ghirri/. Ghirri also referred to his images as "sentimental geography" or "indifferent cartography." He saw them as melancholic: "Melancholy is the road sign for an effaced geography, it is the feeling of distance that separates us from a potential simple world." Christy Lange, "All Other Images," *Frieze,* November 1, 2011, https://frieze.com/article/all-other-images. Thomas Demand brought Ghirri to the attention of an American audience in 2011 with the exhibition *La Carte d'après nature* that he curated at Matthew Marks.

27 *James Casebere: Works 1975–2010,* ed. Okwui Enwezor (Bologna: Damiani, 2011), p. 31.

28 Casebere's model for *Landscape with Houses, Dutchess County* began as a four-by-five-foot construction, grew to ten by sixteen feet, and then expanded to sixteen by twenty feet.

29 https://www.guggenheim.org/artwork/4383

30 *Thomas Demand*, with texts by Francesco Bonami, Régis Durand, and François Quintin (London: Thames & Hudson; and Paris: Fondation Cartier pour l'Art Contemporain, 2001), p. 25.

31 Statement on webpage for *Model Studies* exhibition, January 28–April 15, 2012, Nottingham Contemporary, Nottingham, England, http://www.nottinghamcontemporary.org/art/thomas-demand.

32 Sean O'Hagan, "Thomas Struth's Photography," *The Guardian,* July 2, 2011, https://www.theguardian.com/artanddesign/gallery/2011/jul/03/thomas-struth-photography.

33 "Unconscious Places 2," *Thomas Struth: Photographs 1978–2010*, online cat., http://www.thomasstruth32.com/smallsize/photographs/unconscious_places_2/index.html.

34 Struth was introduced to Stephen Shore's influential work during the 1970s, when he studied at the Kunstakademie in Düsseldorf under Bernd and Hilla Becher, Joseph Beuys, Gerhard Richter, and Sigmar Polke. He and fellow students Candida Höfer, Andreas Gursky, and Thomas Ruff were also influenced by the Bechers' conceptual photographs, an archive of serial images of anonymous traditional buildings in black-and-white and arranged in grids, as well as by Eugène Atget's deserted Paris street scenes. Struth's book *Thomas Struth: Unconscious Places* (Munich: Schirmer/Mosel, 2012) pays homage to Shore's 1982 book *Uncommon Places.*

35 The altar was originally built during the second century BCE on one of the terraces of the acropolis in the ancient Greek city of Pergamon in Asia Minor. At the beginning of the twentieth century, over two thousand fragments of the reassembled frieze and reconstructed altar were housed in a temporary building. The Pergamon Museum, located on Berlin's Museum Island, was built between 1910 and 1930, and was badly damaged by Allied bombs during World War II. For a discussion, see Can Bilsel, *Antiquity on Display: Regimes of the Authentic in Berlin's Pergamon Museum* (Oxford: Oxford University Press, 2012).

36 Interview by Sarah Phillips, "Photography: My Best Shot: Candida Höfer's Best Photograph," *The Guardian,* February 6, 2013, https://www.theguardian.com/artanddesign/2013/feb/06/candida-hofer-best-photograph..

37 The Mouchotte Building was designed by Jean Dubuisson in 1959 and built between 1959 and l968 on Rue du Commandant René Mouchotte.

38 The effect of Gursky's image has been likened to the contemporary urban sublime. See Terrie Sultan, *Andreas Gursky: Landscapes* (Southampton, NY: Parrish Art Museum; and New York: Gagosian, 2015), and Alix Ohlin, "Andreas Gursky and the Contemporary Sublime," *Art Journal* 61, no. 4 (2002), pp. 22–35, mediaediting.wikispaces.asu.edu/file/view/778148.pdf.

39 Alexandra Lange, "Reducing Spectacular to Simple: Questions for Hélène Binet, Architectural Photographer," *The New York Times*, February 25, 2015, http://www.nytimes.com/2015/02/26/garden/questions-for-helene-binet-architectural-photographer.html.

40 Ibid.

41 By 2014, the population of Torre David exceeded 2,500 (approximately 700 families), and the government relocated all the occupants to a new housing complex more than an hour from Caracas. As of 2016, the Torre David remained unfinished and unoccupied.

42 Siegfried Kracauer, "Photography," trans. Thomas Y. Levin, *Critical Inquiry* 19 (Spring 1993), p. 424. The original German article, "Die Photographie," was first published in the *Frankfurter Zeitung*, October 28, 1927.

43 Interview with Philip Pocock, *Journal of Contemporary Art*, http://www.jca-online.com/ruff.html.

Exhibition Checklist

Dimensions are in inches; height precedes width precedes depth.

1. Berenice Abbott (American, 1898–1991)
The Night View, 1934 (printed 1974)
Gelatin silver print
13¾ × 10¾
The Museum of the City of New York, 79.147.2
Plate 2, p. 25

2. Berenice Abbott (American, 1898–1991)
Changing New York; Columbus Circle, 1936
Gelatin silver print
9½ × 7½
The Museum of the City of New York, Gift of the Metropolitan
Museum of Art, 1949, 49.282.160
Plate 3, p. 41

3. Robert Adams (American, born 1937)
Colorado Springs, Colorado, 1968
Gelatin silver print
14½ × 14½
Collection of Stacy and Lance Boge, New York, courtesy
Matthew Marks Gallery, New York
Plate 36, p. 92

4. Robert Adams (American, born 1937)
Colorado Springs, Colorado, 1968–1971
Gelatin silver print
13 × 11
Courtesy Matthew Marks Gallery, New York
Plate 34, p. 90

5. Robert Adams (American, born 1937)
Golden, Colorado, 1968–1971
Gelatin silver print
10 × 8
Courtesy Matthew Marks Gallery, New York
Plate 35, p. 91

6. Robert Adams (American, born 1937)
Lakewood, Colorado, 1973
Gelatin silver print
11 × 14
Courtesy Matthew Marks Gallery, New York
Plate 37, p. 93

7. Iwan Baan (Dutch, born 1975)
Torre David #1, 2011
Chromogenic print
72 × 48
Courtesy the artist and Moskowitz Bayse, Los Angeles
Plate 56, p. 134

8. Iwan Baan (Dutch, born 1975)
Torre David #2, 2011
Chromogenic print
48 × 72
Courtesy the artist and Moskowitz Bayse, Los Angeles
Plate 57, p. 135

9. Iwan Baan (Dutch, born 1975)
The City and the Storm, 2012
Chromogenic print
72 × 48
Courtesy the artist and Moskowitz Bayse, Los Angeles
Plate 4, p. 43

10. Lewis Baltz (American, 1945–2014)
Tract House #5, from *The Tract Houses* portfolio, 1971
Gelatin silver print
5¾ × 8⅜
George Eastman Museum, Rochester, New York
Plate 33, p. 89

11. Lewis Baltz (American, 1945–2014)
Tract House #6, from *The Tract Houses* portfolio, 1971
Gelatin silver print
5½ × 8⅛
George Eastman Museum, Rochester, New York
Plate 30, p. 86

12. Lewis Baltz (American, 1945–2014)
Tract House #8, from *The Tract Houses* portfolio, 1971
Gelatin silver print
5⁹⁄₁₆ × 8⁷⁄₁₆
George Eastman Museum, Rochester, New York
Plate 32, p. 88

13. Lewis Baltz (American, 1945–2014)
Tract House #23, from *The Tract Houses* portfolio, 1971
Gelatin silver print
5½ × 8⅞
George Eastman Museum, Rochester, New York
Plate 31, p. 87

14. Hélène Binet (Swiss-French, born 1959)
*Feldkapelle für den heiligen Bruder Klaus 06 (Architecture by
Peter Zumthor)*, 2007
Gelatin silver print
23¾ × 19¾
Courtesy Ammann Gallery, Cologne, Gabrielle Ammann
Plate 54, p. 130

15. Hélène Binet (Swiss-French, born 1959)
*Christ Church in Spitalfields 02 (Architecture by Nicholas
Hawksmoor)*, 2013
Gelatin silver print
60 × 47
Courtesy Ammann Gallery, Cologne, Gabrielle Ammann
Plate 55, p. 131

16. James Casebere (American, born 1953)
Landscape with Houses (Dutchess County, NY) #2, 2009
Chromogenic print mounted to Dibond
69¾ × 106
Collection of Marcia Dunn and Jonathan Sobel, New York
Plate 46, pp. 112–113

17. James Casebere (American, born 1953)
Yellow Overhang with Patio, 2016
Archival pigment print mounted to Dibond
44³/₈ × 66¹/₂
Courtesy the artist and Sean Kelly, New York
Plate 47, p. 115

18. Thomas Demand (German, born 1964)
Flur (Corridor), 1995
Chromogenic print mounted on Diasec
72 × 106
Courtesy Matthew Marks Gallery, New York
Plate 51, p. 127

19. Thomas Demand (German, born 1964)
Modell, 2000
Chromogenic print mounted on Diasec
64³/₄ × 82¹/₂
Courtesy Matthew Marks Gallery, New York
Plate 50, p. 126

20. Luigi Ghirri (Italian, 1943–1992)
Modena, from the series *Catalogo*, 1971
Chromogenic print
4³/₄ × 6³/₄
Courtesy Matthew Marks Gallery, New York
Plate 41, p. 104

21. Luigi Ghirri (Italian, 1943–1992)
Modena, from the series *Catalogo*, 1972
Chromogenic print
6³/₄ × 4³/₄
Courtesy Matthew Marks Gallery, New York
Plate 42, p. 105

22. Luigi Ghirri (Italian, 1943–1992)
Bonn, from the series *Kodachrome*, 1973
Chromogenic print
7¹/₄ × 9³/₄
Courtesy Matthew Marks Gallery, New York
Plate 43, p. 106

23. Luigi Ghirri (Italian, 1943–1992)
Reggio Emilia, from the series *Kodachrome*, 1973
Chromogenic print
5 × 7
Collection of Ted and Mary Jo Shen, New York, courtesy
Matthew Marks Gallery, New York
Plate 40, p. 103

24. Luigi Ghirri (Italian, 1943–1992)
Rimini, from the series *Italia ailati*, 1977
Chromogenic print
5¹/₈ × 6³/₄
Courtesy Matthew Marks Gallery, New York
Plate 44, p. 107

25. Samuel H. Gottscho (American, 1875–1971)
New York City views, RCA Building floodlighted, 1933
Gelatin silver print
7 × 5
The Gottscho-Schleisner Collection, The Museum of the City
of New York, Gift of Samuel H. Gottscho/Gottscho-Schleisner,
88.1.2.2267
Plate 9, p. 54

26. Samuel H. Gottscho (American, 1875–1971)
North from the RCA Building, 1934
Gelatin silver print
9¹/₄ × 13¹/₂
The Museum of the City of New York, Gift of Samuel H.
Gottscho, 1934, 34.102.3
Plate 6, p. 46

27. Samuel H. Gottscho (American, 1875–1971)
Southeast from the RCA Building, 1934
Gelatin silver print
11 × 16¹/₂
The Museum of the City of New York,
Gift of Samuel H. Gottscho, 1934, 34.102.4
Plate 5, pp. 44–45

28. Andreas Gursky (German, born 1955)
Avenue of the Americas, 2001
Chromogenic print
81¹/₄ × 140¹/₄ × 2¹/₂
Courtesy Gagosian
Plate 49, p. 125

29. Candida Höfer (German, born 1944)
Villa Borghese Roma III 2013, 2013
Chromogenic print
70⁷/₈ × 80¹/₈
Courtesy Sean Kelly, New York and Sonnabend Gallery,
New York
Plate 48, p. 119

30. Balthazar Korab (Hungarian, 1926–2013)
860–880 Lake Shore Drive Apartments, Chicago, IL, 1960
Chromogenic print with metallic paper base
11 × 11
Courtesy Korab Image, Christian Korab, Minnesota
Plate 24, p. 71

31. Balthazar Korab (Hungarian, 1926–2013)
*TWA Flight Center in JFK International Airport (Queens,
New York)*, 1964
Gelatin silver print
11 × 14
Courtesy Korab Image, Christian Korab, Minnesota
Plate 22, p. 69

32. Balthazar Korab (Hungarian, 1926–2013)
Toronto-Dominion Centre, 1960s
Gelatin silver print
16 × 20
Courtesy Korab Image, Christian Korab, Minnesota
Plate 23, p. 70

33. Thomas Ruff (German, born 1958)
d.p.b. 02, 1999
Chromogenic print
51¼ × 75¼
Private Collection, courtesy David Zwirner Gallery,
New York/London
Plate 7, p. 52

34. Thomas Ruff (German, born 1958)
w.h.s. 10, 2001
Chromogenic print
75 × 94½
Collection of George Yabu and Glenn Pushelberg, courtesy
David Zwirner Gallery, New York/London
Plate 8, p. 53

35. Ed Ruscha (American, born 1937)
Every Building on the Sunset Strip, 1966
Artist's book
7⁵/₁₆ × 5¹³/₁₆ × ⁹/₁₆
Collection of Beth Rudin DeWoody, New York
Plate 1, pp. 4–5

36. Stephen Shore (American, born 1947)
*Church Street and Second Street, Easton, Pennsylvania,
June 20, 1974*, 1974 (printed 2013)
Chromogenic print
12¼ × 15¼
Courtesy 303 Gallery, New York
Plate 38, p. 100

37. Stephen Shore (American, born 1947)
*Second Street, East and South Main Street, Kalispell, Montana,
Aug. 22, 1974*, 1974 (printed 2009)
Chromogenic print
14³/₈ × 18¹/₁₆
Courtesy 303 Gallery, New York
Plate 39, p. 101

38. Julius Shulman (American, 1910–2009)
Academy Theater, exterior (Inglewood, Calif.), 1940
Gelatin silver print
9¹⁵/₁₆ × 7¹⁵/₁₆
Julius Shulman Photography Archive, Getty Research Institute,
Los Angeles, 2004.R.10
Plate 13, p. 58

39. Julius Shulman (American, 1910–2009)
Academy Theater, interior (Inglewood, Calif.), 1940
Gelatin silver print
10³/₁₆ × 8¹/₁₆
Julius Shulman Photography Archive, Getty Research Institute,
Los Angeles, 2004.R.10
Plate 14, p. 59

40. Julius Shulman (American, 1910–2009)
Loewy (Raymond) House (Palm Springs, Calif.), 1947
Gelatin silver print
8 × 10
Julius Shulman Photography Archive, Getty Research Institute,
Los Angeles, 2004.R.10
Plate 29, p. 79

41. Julius Shulman (American, 1910–2009)
Chuey House (Los Angeles, Calif.), 1956
Gelatin silver print
9¹⁵/₁₆ × 7¹⁵/₁₆
Julius Shulman Photography Archive, Getty Research Institute,
Los Angeles, 2004.R.10
Plate 26, p. 74

42. Julius Shulman (American, 1910–2009)
Case Study House No. 22 (Los Angeles, Calif.), 1960
Gelatin silver print
9¹⁵/₁₆ × 7¹⁵/₁₆
Julius Shulman Photography Archive, Getty Research Institute,
Los Angeles, 2004.R.10
Plate 27, p. 75

43. Julius Shulman (American, 1910–2009)
Case Study House No. 22 (Los Angeles, Calif.), 1960
Gelatin silver print
8 × 10
Julius Shulman Photography Archive, Getty Research Institute,
Los Angeles, 2004.R.10
Plate 28, p. 77

44. Julius Shulman (American, 1910–2009)
Singleton House (Los Angeles, Calif.), 1960
Gelatin silver print
14 × 11¼
Julius Shulman Photography Archive, Getty Research Institute,
Los Angeles, 2004.R.10
Plate 25, p. 73

45. Julius Shulman (American, 1910–2009)
Brasília Buildings (Brasília, Brazil), 1977
Gelatin silver print
8 × 10
Julius Shulman Photography Archive, Getty Research Institute,
Los Angeles, 2004.R.10
Plate 16, p. 62

46. Ezra Stoller (American, 1915–2004)
*Johnson Wax Administration Building and Research Tower,
Frank Lloyd Wright, Racine, WI*, 1950
Gelatin silver print
20 × 16
Courtesy Yossi Milo Gallery, New York
Plate 19, p. 65

47. Ezra Stoller (American, 1915–2004)
Notre Dame du Haut, Ronchamp Chapel, Le Corbusier,
Ronchamp, France, 1955
Gelatin silver print
16 × 20
Courtesy Yossi Milo Gallery, New York
Plate 11, p. 56

48. Ezra Stoller (American, 1915–2004)
Seagram Building, Mies van der Rohe with Philip Johnson,
New York, NY, 1958
Gelatin silver print
20 × 16
Courtesy Yossi Milo Gallery, New York
Plate 18, p. 64

49. Ezra Stoller (American, 1915–2004)
TWA Terminal at Idlewild (now JFK) Airport, Eero Saarinen,
New York, NY, 1962
Chromogenic print
16 × 20
Courtesy Yossi Milo Gallery, New York
Plate 21, p. 68

50. Ezra Stoller (American, 1915–2004)
Hirshhorn Museum, Skidmore, Owings & Merrill,
Washington, D.C., 1974
Gelatin silver print
16 × 20
Courtesy Yossi Milo Gallery, New York
Plate 17, p. 63

51. Thomas Struth (German, born 1954)
Las Vegas 1, Nevada, 1999
Chromogenic print
55¾ × 80½
Private collection, courtesy 601 Artspace, New York
Plate 53, p. 129

52. Thomas Struth (German, born 1954)
Dallas Parking Lot, Dallas, 2001
Chromogenic print mounted on Plexiglas
69½ × 97¼
Dallas Museum of Art, Gift of the artist and Marian Goodman
Gallery, New York, 2002.51
Plate 52, p. 128

53. Thomas Struth (German, born 1954)
Pergamon Museum 1, Berlin, 2001
Chromogenic print
80¾ × 100¾
Dallas Museum of Art, Contemporary Art Fund: Gift of Arlene
and John Dayton, Mr. and Mrs. Vernon E. Faulconer, Mr. and Mrs.
Bryant M. Hanley, Jr., Marguerite and Robert K. Hoffman, Cindy
and Howard Rachofsky, Deedie and Rusty Rose, Gayle and Paul
Stoffel, and three anonymous donors, 2002.46
Plate 45, p. 109

54. Hiroshi Sugimoto (Japanese, born 1948)
Radio City Music Hall, New York, 1978
Gelatin silver print
47 × 58¾
Courtesy the artist and Marian Goodman Gallery, New York
Plate 15, p. 61

55. Hiroshi Sugimoto (Japanese, born 1948)
Seagram Building, 1997
Gelatin silver print
58¾ × 47
Courtesy the artist
Plate 20, p. 67

56. Hiroshi Sugimoto (Japanese, born 1948)
Chapel of Notre Dame du Haut, 1998
Gelatin silver print
58¾ × 47
Courtesy the artist
Plate 12, p. 57

57. Hiroshi Sugimoto (Japanese, born 1948)
Rockefeller Center, 2001
Gelatin silver print
58¾ × 47
Courtesy the artist
Plate 10, p. 55

Author's Acknowledgments

This book has been developed in conjunction with the exhibition *Image Building: How Photography Transforms Architecture*, organized by the Parrish Art Museum in Water Mill, NY. The exhibition and book grew out of my love for architecture and photography and was first inspired by the Parrish Art Museum's building, designed by Herzog & de Meuron. I first want to thank Terrie Sultan, Director of the Parrish Art Museum, who invited me to curate the exhibition and encouraged me throughout the process. I would also like to thank the other members of the team at the Parrish: Alicia Longwell, The Lewis B. and Dorothy Cullman Chief Curator, Michael Pinto, Curatorial Associate, and Chris McNamara, Registrar, for their dedication and support.

I am especially grateful to the sustenance of friends and colleagues: Maurice Berger and Marvin Heiferman, whose constant ideas and encouragement helped shape this project and bring it to life; Marvin Heiferman's insightful essay in the book has enhanced this project. Special thanks to Alexandra Cromwell for her thoughtful editorial feedback and generous support, Nancy Cohen for numerous invaluable conversations and editing, and Allen S. Weiss for his engaging conversations and helpful advice. I appreciate a number of colleagues and friends for their cooperation and support in making this project happen including: Courtney Sale Ross, Founder of the Ross School, Jennifer Cross, Susan H. Edwards, Executive Director and CEO, Frist Center for the Visual Arts, Lala Weiss, and my husband, Stanley Gans. Lastly, I want to express my deepest gratitude to my mentor, the late Linda Nochlin, for her support, guidance, and inspiration.

THERESE LICHTENSTEIN

PHOTO CREDITS

Photographs in this book have been provided by the owners or custodians of the work. The following list applies to those for which a separate credit is due. Individual photographer names are provided when available. Every effort has been made to obtain rights from image rights holders. Any information on unlocated rights holders forwarded to the museum will be acted upon in future editions.

Pl. 2: Image courtesy Philadelphia Museum of Art, © 2018 Estate of Berenice Abbott/ Getty Images; pl. 3: © 2018 Estate of Berenice Abbott/ Berenice Abbott for Federal Art Project/ Getty Images/ The Museum of the City of New York; pls. 4, 56, 57: © 2018 Iwan Baan; pls. 5, 6, 9: © 2018 Estate of Samuel H. Gottscho/ The Museum of the City of New York; pls. 7, 8: © 2018 Thomas Ruff/ Artists Rights Society (ARS), New York/ VG Bild-Kunst, Bonn; pls. 10, 12, 15, 20: Images courtesy Fraenkel Gallery, San Francisco/ Marian Goodman Gallery, New York, © 2018 Hiroshi Sugimoto; pls. 11, 17–19, 21: © 2018 Estate of Ezra Stoller/ Esto; pls. 13, 14, 16, 25–29: © 2018 Estate of Julius Shulman/ J. Paul Getty Trust, Getty Research Institute, Los Angeles; pls. 22–24: © 2018 Korab Image; pls. 30–32: Images courtesy Estate of Lewis Baltz and Gallery Luisotti, Santa Monica, © 2018 Estate of Lewis Baltz; pl. 33: Image courtesy Estate of Lewis Baltz and Gallery Luisotti, Santa Monica, © 2018 Estate of Lewis Baltz, Photo by Don Ross; pls. 34–37: © 2018 Robert Adams, Images courtesy Fraenkel Gallery, San Francisco and Matthew Marks Gallery, New York; pls. 38, 39: © 2018 Stephen Shore; pls. 40–44: ©Estate of Luigi Ghirri; pls. 45, 52, 53: Images courtesy Thomas Struth Studio, © 2018 Thomas Struth; pl. 46: Image courtesy the artist and Sean Kelly, New York, © 2018 James Casebere; pl. 47: © 2018 James Casebere; pl. 48: © 2018 Candida Höfer, Köln/ Artists Rights Society (ARS), New York/ VG Bild-Kunst, Bonn; pl. 49: © 2018 Andreas Gursky/ Artists Rights Society (ARS), New York/ VG Bild-Kunst, Bonn/ Courtesy Sprüth Magers Berlin London; pls. 50, 51: © 2018 Thomas Demand/ Artists Rights Society (ARS), New York/ VG Bild-Kunst, Bonn; pls. 54, 55: © 2018 Hélène Binet.